HOW TO DRAW
Grimm's Dark Tales,
FABLES & FOLKLORE

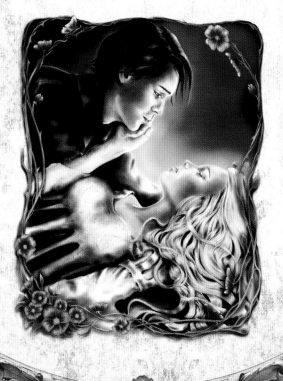

Instructional step-by-step text by Rachel A. Marks

Publisher: Rebecca J. Razo
Project Editor: Stephanie Meissner
Art Director: Shelley Baugh
Associate Editor: Jennifer Gaudet
Assistant Editor: Janessa Osle
Production Designers: Debbie Aiken, Amanda Tannen
Production Manager: Nicole Szawlowski
International Purchasing Coordinator: Lawrence Marquez
Production Assistant: Jessi Mitchelar

www.walterfoster.com
3 Wrigley, Suite A
Irvine, CA 92618

Printed in China.
3 5 7 9 10 8 6 4 2
18471

FANTASY UNDERGROUND

HOW TO DRAW
Grimm's Dark Tales,
FABLES & FOLKLORE

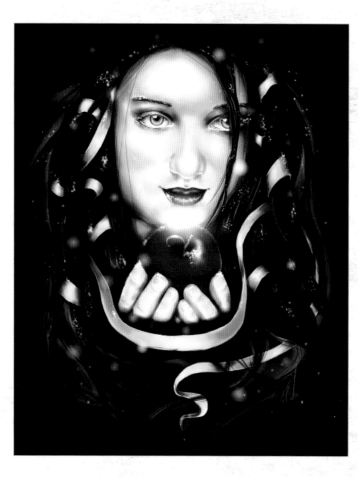

ILLUSTRATED BY RACHEL A. MARKS & WRITTEN BY MERRIE DESTEFANO

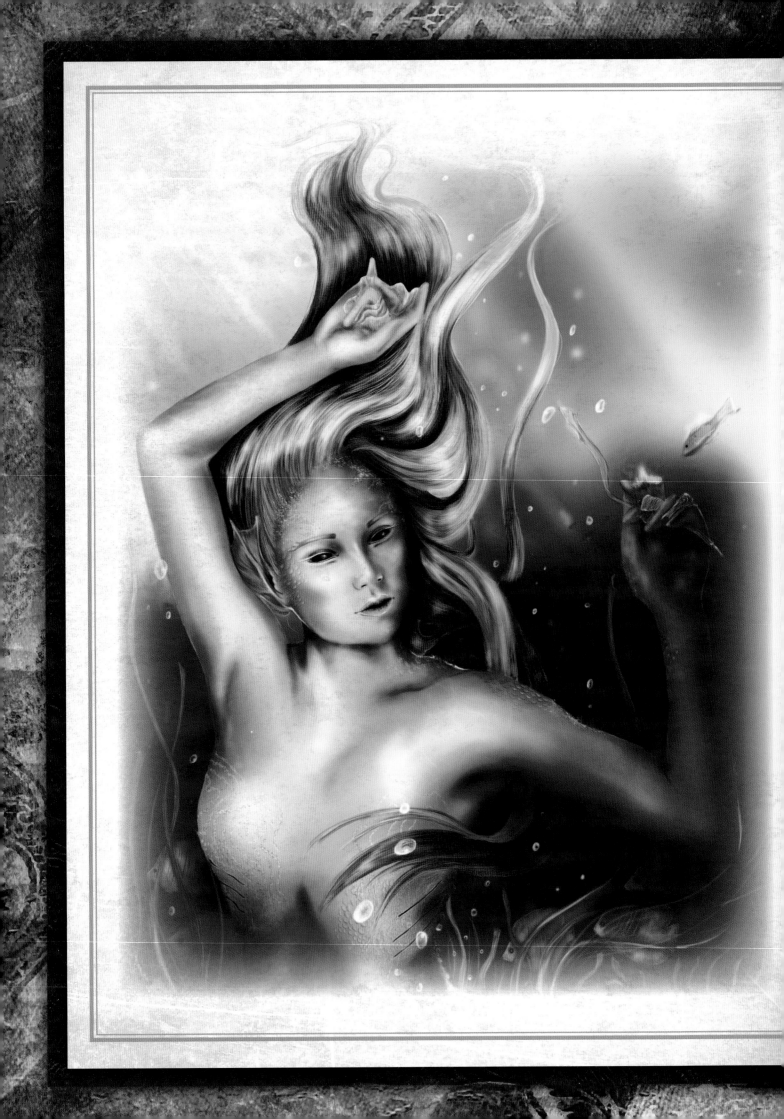

Contents

Chapter 1

INTRODUCTION

There's no fairy godmother coming to rescue you in this book.

Instead, you might be saved by a pair of birds who turn around and peck out the eyes of your stepsisters or by a huntsman who cuts you out of a wolf's stomach. You may be rescued from an ivory tower by a prince—but he will be blinded first and later healed by your tears.

Until now, most of the Grimm fairy tales you've heard have been altered, the macabre details of murder and dismemberment and cannibalism removed.

Fortunately, this is no ordinary illustrated fairy tale book, for this book is based on the Brothers Grimm original folktales, written in 1812. Inside you'll not only discover the secrets of the dark, malevolent, and mysterious fairy-tale characters of legend and lore— you'll learn to draw them too.

So, consider yourself warned. You're entering the Fantasy Underground, and these are the sorts of stories that might just keep you up all night long.

History of
Grimm's Fairy Tales

The best stories can only be told in the dark. Macabre tales of children being eaten, stepsisters being blinded, and murderous bridegrooms eager to devour their young brides—stories like these need the darkness.

So it's no surprise that the dawning of the Industrial Revolution in the early 1800s brought change, even to the ancient arena of oral storytelling. Kerosene lanterns chased away the darkness, bringing so much light that people began to spend their evenings differently— reading newspapers and books. As a result, the folktales Jacob and Wilhelm Grimm had heard from childhood were no longer being told.

This was also the height of the Romantic Movement, a time when artists, poets, and historians sought to immortalize the Renaissance through art and literature. As academics, librarians, and professors, the Grimm brothers eagerly joined their friends on this noble quest, albeit with a different goal. Rather than focusing on the Middle Ages, Jacob and Wilhelm opted to preserve German culture for future generations by transcribing regional folktales.

For years, they invited storytellers into their home, listening and writing down what they heard, only occasionally changing a French term to a more familiar German phrase. As a result, all the fairies and fey became wise women and enchantresses. There is no fairy godmother in the

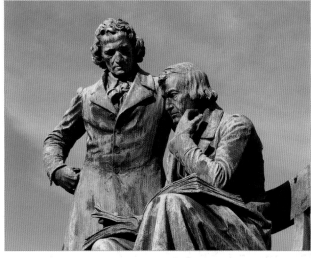

The Brothers Grimm statue in Hanau, Germany.

original version of "Cinderella," no fairies in "Sleeping Beauty." While the brothers slightly altered the stories to remove French influences and to add in references to God, they did not remove the dark heart of the stories themselves.

Set amidst a backdrop of forests and castles, these folktales were later translated into more than 160 languages and went on to inspire countless books and films, including many beloved animated Disney movies such as *Snow White and the Seven Dwarfs* (c. 1937), *Cinderella* (c. 1950), and *Sleeping Beauty* (c. 1959). The stories continue to inspire literature, television series, feature films, and pop culture today.

Although the original Grimm fairy tales featured elements of magic and true love—of princes who chose scullery maids over royalty, of enchanted frogs turning into handsome lords—the original stories

have been heavily edited over the years. In the beginning, these tales contained sinister elements of cannibalism, murder, vengeance, and judgment. There were stories of cruel stepmothers forced to wear red-hot iron shoes ("Cinderella"), of girls willing to cut off their own fingers to save their brothers ("The Seven Ravens"), of children eaten by wolves ("Red Riding Hood"), and of young girls imprisoned and isolated in high towers ("Rapunzel").

The earliest versions of the Grimm fairy tales also included sexuality (apparently Rapunzel and her prince weren't chaste in their tower meetings) and violence (the frog king wasn't kissed, but rather thrown against a wall). But this was because the brothers never intended their stories for a young audience.

Published in 1812, the Grimm brothers' first collection of folktales, *Kinder-Und Hausmärchen*, contained 86 stories; from the very beginning, they were asked to censor them. The brothers refused and instead added an introduction to the collection, noting that parents should only read age-appropriate stories to their children.

Despite the fact that their stories were censured and criticized for being too violent, Jacob and Wilhelm approached their work with the eyes of Romantic artists and historians, hoping to preserve traditions that they believed were passing away. As a result, Grimm's Fairy Tales have become enduring classics, perhaps because these stories don't varnish over the darkness that hides in the human heart. Rather, Jacob and Wilhelm chose to reveal the true quality of the human soul—in grim detail.

Tools & Materials

On the following pages, you'll learn about the tools and materials you will need to complete the projects in this book.

DRAWING SUPPLIES

▶ SKETCH PADS

Sketch pads come in many shapes and sizes. Most are not designed for finished artwork, but they are helpful for working out your ideas.

PAPER

Drawing paper is available in a range of surface textures: smooth grain (plate finish and hot-pressed), medium grain (cold-pressed), and rough to very rough. Rough paper is ideal when using charcoal; smooth paper is best for watercolor washes. The heavier the paper, the thicker its weight. Thick paper is better for graphite drawing because it can withstand erasing better than thin paper.

COLORED PENCILS

Colored pencils come in wax-based, oil based, and water-soluble versions. Oil-based pencils complement wax pencils nicely. Water-soluble pencils react to water in a manner similar to watercolor. In addition to creating finished art, colored pencils are useful for enhancing small details.

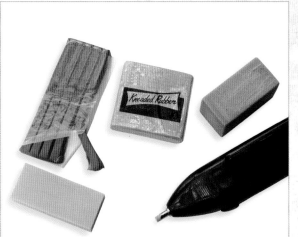

ART MARKERS

Alcohol-based art markers offer a nice finish when applied to photocopies, but make sure that the photocopy toner is dry before applying color. Markers and colored pencils may also be used in combination with paint to further enhance and accent your drawings.

ERASERS

There are several types of art erasers. Plastic erasers are useful for removing hard pencil marks and large areas. Kneaded erasers can be molded into different shapes and used to dab an area, gently lifting tone from the paper.

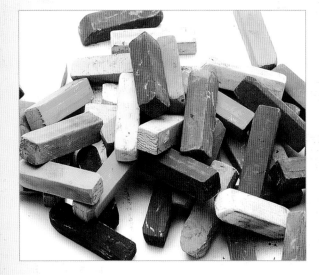

PASTELS

Soft pastels, like those pictured here, are perfect for laying down undercoats of color. Hard pastels are useful for creating detail, such as hair, whiskers, and blades of grass. Pastels work best with toothy paper that has a lot of texture.

OTHER DRAWING ESSENTIALS

Other tools you may need for drawing include a ruler or T-square for marking the perimeter of your drawing area; artist's tape for attaching your drawing paper to a table or board; pencil sharpeners; blending stumps, or "tortillons," to blend or soften small areas; a utility knife for cutting drawing boards; and an open, well-lighted work station.

DRAWING PENCILS

Artist's pencils contain a graphite center and are sorted by hardness (grade) from very soft (9B) to very hard (9H). A good starter set includes a 6B, 4B, 2B, HB, B, 2H, 4H, and 6H. Pencil grade is not standardized, so your first set should be from the same brand for consistency.

- Very hard: 5H - 9H
- Hard: 3H - 4H
- Medium hard: H - 2H
- Medium: HB - F
- Medium soft: B - 2B
- Soft: 3B - 4B
- Very soft: 5B - 9B

Drawing Techniques

By using various hand positions and shading techniques, you can produce a world of different stroke shapes, lengths, widths, and weights in pencil. It's also important to notice your pencil point. The shape of the tip is as essential as the type of pencil lead. Experiment with different hand positions and techniques to see what your pencil can do.

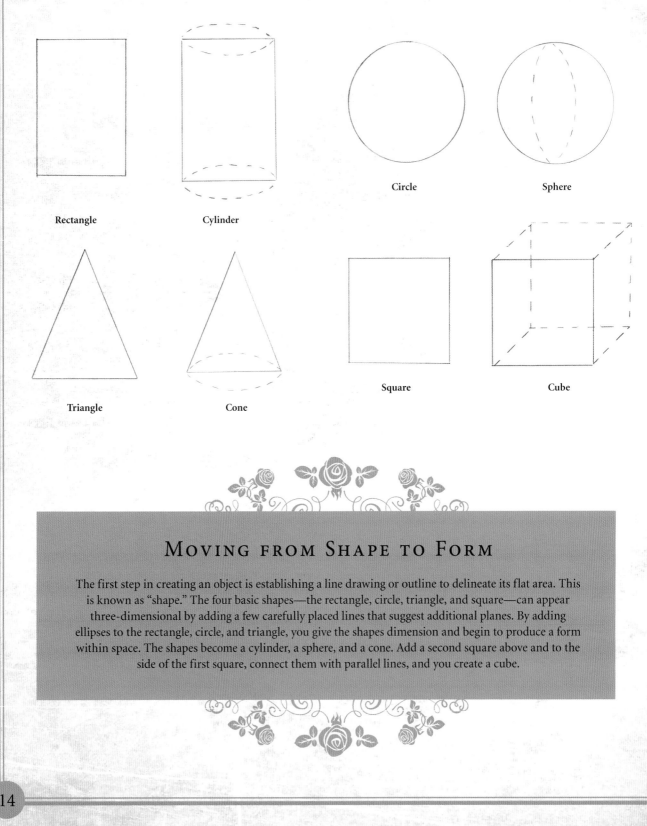

Rectangle Cylinder Circle Sphere

Triangle Cone Square Cube

MOVING FROM SHAPE TO FORM

The first step in creating an object is establishing a line drawing or outline to delineate its flat area. This is known as "shape." The four basic shapes—the rectangle, circle, triangle, and square—can appear three-dimensional by adding a few carefully placed lines that suggest additional planes. By adding ellipses to the rectangle, circle, and triangle, you give the shapes dimension and begin to produce a form within space. The shapes become a cylinder, a sphere, and a cone. Add a second square above and to the side of the first square, connect them with parallel lines, and you create a cube.

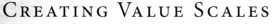

CREATING VALUE SCALES

Artists use scales to measure changes in value and to gauge how dark to make dark values and how light to make highlights. Value scales also serve as a guide for transitioning from lighter to darker shades. Making your own value scale will help familiarize you with the different variations in value. Work from light to dark, adding more and more tone for successively darker values (as shown above left). Then create a blended value scale by using a blending stump to blend each value into its neighboring value from light to dark to create a gradation (as shown above right).

BASIC TECHNIQUES

The basic pencil techniques below can help you learn to render everything from people to buildings. Whatever techniques you choose, remember to shade evenly in a back-and-forth motion over the same area, varying the spot where the pencil point changes direction.

HATCHING
This technique consists of a series of parallel strokes. The closer the strokes, the darker the tone will be.

CROSSHATCHING
For darker shading, layer parallel strokes on top of one another at varying angles.

GRADATING
To create gradated values (from dark to light), apply heavy pressure with the side of your pencil, gradually lightening as you go.

SHADING DARKLY
Apply heavy pressure to the pencil to create dark, linear areas of shading.

SHADING WITH TEXTURE
For a mottled texture, use the side of the pencil tip to apply small, uneven strokes.

BLENDING
To smooth out the transitions between strokes, gently rub the lines with a blending tool or your finger.

Creating Textures

Textures should be rendered based on how the light source affects the form of the object. Don't confuse texture with pattern, which is the tone or coloration of the material. Think of texture as a series of forms (or lack thereof) on a surface. Here are some examples.

LONG HAIR
Long hair has a direction and a flow to its texture. Its patterns depend on the weight of the strands and stress points. Long hair gathers into smaller forms. Treat each smaller form as part of the larger form. Remember that each form will be affected by the same global light source.

SCALES
Drawn as a series of interlocking stacked plates, scales become more compressed as they follow forms that recede from the picture plane.

METAL
Polished metal is a mirrored surface and reflects a distorted image of whatever is around it. Metal can range from slightly dull (as shown here) to sharp and mirror-like. The shapes reflected will be abstract with hard edges, and the reflected light will be very bright.

FEATHERS AND LEAVES
Stiff feathers or leaves are long and a bit thick. The forms closest to the viewer are compressed; those farther away from the viewer are longer.

WOOD
Rough, unfinished wood is made up of swirling lines. There is a rhythm and direction to the pattern that you need to observe and then feel out in your drawings.

SHORT, FINE HAIR
Starting at the point closest to the viewer, the hairs point toward the picture plane and can be indicated as dots. Moving out and into shadowed areas, the marks become longer and more dense.

CLOTH
The texture of cloth depends on the thickness and stiffness of the material. Thinner materials have more wrinkles that bunch and conform to shapes more perfectly. As wrinkles move around a form and away from the picture plane, they compress and become more dense.

ROPE
The series of braided cords that make up rope create a pattern that compresses as it wraps around a surface and moves away from the picture plane.

Perspective Basics

Perspective provides the visual cues that help create the illusion of depth and distance in a drawing. Eye level changes as your elevation of view changes. In perspective, eye level is indicated by the horizon line. Imaginary lines receding into space meet on the horizon line at what are known as "vanishing points." Any figures drawn along these lines will be in proper perspective. Study the diagrams below.

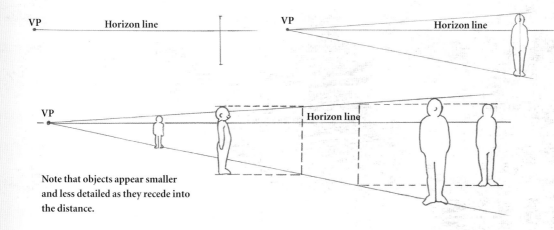

Note that objects appear smaller and less detailed as they recede into the distance.

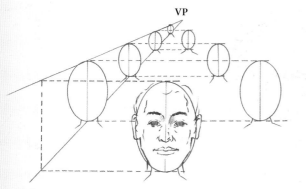

Try drawing a frontal view of many heads as if they were in a theater. (See diagram at left.) Start by establishing your vanishing point at eye level. Draw one large head representing the person closest to you, and use it as a reference for determining the sizes of the other figures in the drawing. The technique illustrated above can be applied when drawing entire figures, shown in the diagram below. Although all of these examples include just one vanishing point, a composition can even have two or three vanishing points.

If you're a beginner, you may want to begin with basic one-point perspective. As you progress, attempt to incorporate two- or three-point perspective.

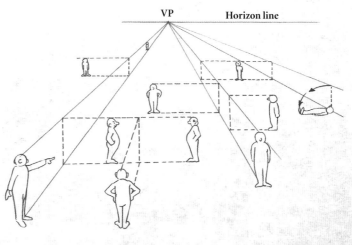

17

Color Theory

The color wheel demonstrates the relationships among colors. *Primary* colors—red, yellow, and blue—are the basis for all other colors on the wheel. When two primary colors are combined, they produce a *secondary* color—green, orange, or purple. When a primary and a secondary color are mixed, they produce a *tertiary* color, such as blue-green or red-orange. Colors directly opposite of one another on the wheel—like yellow and purple—are "complements." Adjacent groups of color on the color wheel—such as green, blue-green, and blue—are "analogous."

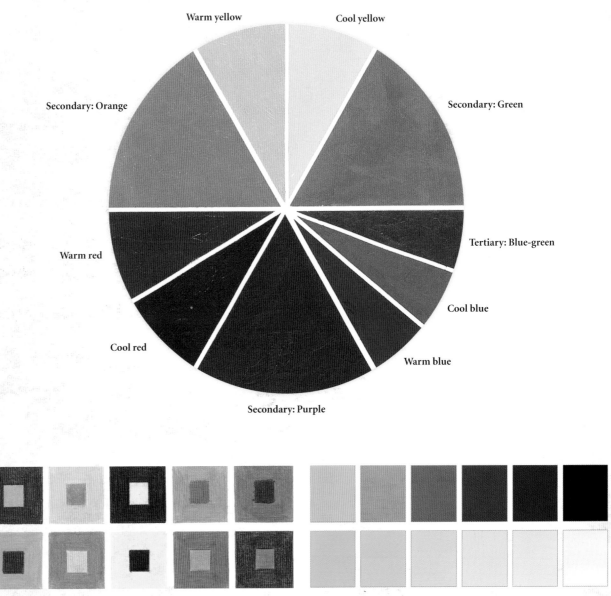

Warm yellow

Cool yellow

Secondary: Orange

Secondary: Green

Tertiary: Blue-green

Warm red

Cool blue

Cool red

Warm blue

Secondary: Purple

USING COMPLEMENTS

When placed next to each other, complementary colors create lively, exciting contrasts. Using a complementary color in the background will cause your subject to "pop."

VALUE SCALES

Value (the lightness or darkness of a color) and its variations are key to creating the illusion of dimension. You can create different values of color using a basic palette. Adding white to a color results in a tint; adding black to a color produces a shade. The top row represents shading, where black is applied to pure color (yellow). In contrast, the bottom row shows tinting, where white is added to pure color (yellow-green).

Colored Pencil Techniques

Painters mix their colors on a palette before applying them to the canvas. With colored pencil, mixing and blending occur directly on the paper. With layering, you can either build up color or create new hues. To deepen a color, layer more of the same over it; to dull a color, use its complement. You can also blend colors by burnishing with a light pencil or using a colorless blender.

LAYERING

Layer one color directly over the other to blend them together. This can be done with as many colors as you think necessary to achieve the color or value desired. The keys to this technique are to use light pressure, work with a sharp pencil point, and apply each layer smoothly.

BURNISHING WITH A COLORLESS BLENDER

Burnishing is a technique that requires heavy pressure to meld two or more colors together for a shiny, smooth look. Using a colorless blender tends to darken the colors.

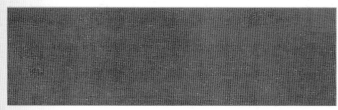

BURNISHING LIGHT OVER DARK

You can burnish using light or white pencils. Place the darker color first; if you place a dark color over a lighter color, the dark color will overcome the lighter color, and no real blending will occur.

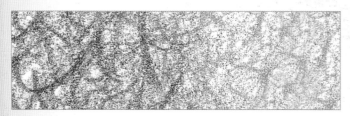

OPTICAL MIXING

In this method, the viewer's eye sees two colors placed next to each other as being blended. Hatch, stipple, or use circular strokes to apply the color, allowing the individual pencil marks to look like tiny pieces of thread. When viewed together, the lines form a tapestry of color that the eye interprets as a solid mass. This is a lively and fresh method of blending that will captivate your audience.

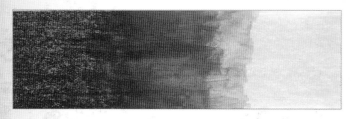

WATERCOLOR EFFECTS

Water-soluble pencils have two uses: to create a traditional colored pencil look and to create a loose, watercolor effect when mixed with water. Lay down several layers of dry color from a pencil and then lightly add water with a small brush, building color with repeated brushings. Once dry, you can restore detail with dry color application.

Pastel Techniques

Pastel is a versatile medium, allowing for an array of artistic approaches. You can make strokes using a wide range of techniques depending upon how the stick is handled and which edge is applied to the paper. Let's look at a few basic approaches.

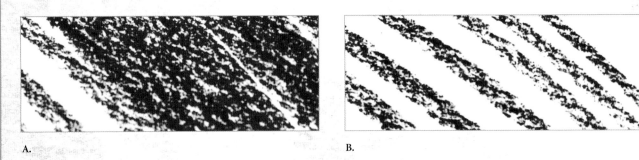

A.
B.

HATCHING

Hatching is achieved by making a series of parallel lines close to each other. Varying the distance and direction of these lines produces a variety of shading effects. Thicker lines hatched closely together appear more dense and dark (A), while thinner lines hatched farther apart appear light and airy (B).

A.
B.

CROSSHATCHING

Crosshatching is created by overlaying hatched lines on top of each other in opposing directions. Crosshatching with the same color deepens the tone and builds up the density of pastel while retaining an open and active feeling (A). Crosshatching with different colors develops a stimulating color effect (B).

SIDE STROKES

A side stroke is created by removing all wrappers and holding the pastel on its side. Drag the long edge of the pastel across the paper to produce a thick, wide stroke. This is an effective way of filling large areas quickly. Using side strokes creates the look of "brushwork" and lends itself to a painterly approach to pastel.

STROKE PRESSURE

Varying the pressure you apply to a stroke yields very different results. A light stroke transfers only a small amount of pastel to the surface, allowing much of the paper to show through. The resulting color appears light and airy. Using heavy pressure fills the tooth of the paper quickly, yielding a dense rich stroke. Try to use a light touch at the beginning of the painting and develop heavier strokes as you gain confidence.

STIPPLING

To stipple, simply apply small dot patterns to the paper to create an impression of form or atmosphere. Use the tip of your pastels to create varying dots of color and tone. When using hard pastels or pencils, stippling creates precise, sharp dots that do not blend together (A). When using soft pastels, the dots appear larger and denser and begin to blur together as more dots are applied (B). This is an effective technique for conveying texture and introducing variety.

A.

B.

A.

B.

GRADATIONS

It is possible to create lovely gradations of color and value by blending with soft pastels. Simply place two colors beside each other (A).
Then use your fingers or a stump to blend the two together at the junction where they meet (B).

Image-Editing Software

These basic Photoshop® functions will guide you as you complete the digital projects in this book.

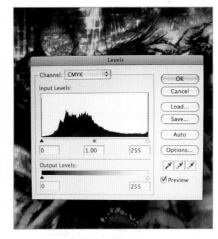

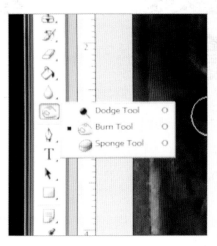

IMAGE RESOLUTION

When scanning your drawing or painting into Photoshop, it's important to scan it at 300 dpi (dots per inch) and 100% the size of the original. A higher dpi carries more pixel information and determines the quality at which your image will print. However, if you intend for the image to be a piece of digital art only, you can set the dpi as low as 72. View the dpi and size under the menu Image > Image Size.

LEVELS

With this tool (under the menu Image > Adjustments), you can change the brightness, contrast, and range of values within an image. The black, midtone, and white of the image are represented by the three markers along the bottom of the graph. Slide these markers horizontally. Moving the black marker right darkens the overall image, moving the white marker left lightens the overall image, and sliding the midtone marker left or right makes the midtones darker or lighter, respectively.

DODGE AND BURN TOOLS

The dodge and burn tools, photography terms borrowed from the old dark room, are also found on the basic tool bar. Dodge is synonymous with lighten; burn is synonymous with darken. On the settings bar under "range," you can select highlights, midtones, or shadows. Select which of the three you'd like to dodge or burn, and the tool will only affect these areas. Adjust the width and exposure (or strength) as desired.

ERASER TOOL

The eraser tool is found in the basic tool bar. When working on a background layer, the tool removes pixels to reveal a white background. You can adjust the diameter and opacity of the brush to control the width and strength of the eraser.

PAINTBRUSH TOOL

The paintbrush tool allows you to apply layers of color to your canvas. Like the eraser, dodge, and burn tools, you can adjust the diameter and opacity of the brush to control the width and strength of your strokes.

COLOR PICKER

Choose the color of your "paint" in the color picker window. Select your hue by clicking within the vertical color bar; then move the circular cursor around the box to change the color's tone.

The Hidden Story

One reason Grimm fairy tales have remained popular for so many years is the fact that there's a moral lesson tucked inside each one. Between the tragedy and triumph, the characters learn something invaluable that changes their lives. Let's take a look at a few of these tales and the dilemmas the characters faced, as well as the lessons they learned along the way.

Red Riding Hood: Warned by her mother to stay on the path while journeying through the forest to visit her grandmother, Red is lured away by a smooth-talking wolf, who later tries to kill both her and her grandmother.
 Lesson: Watch out for strangers.

Godfather Death: Adopted by a supernatural being—Death—a young man is given the power to heal, but it comes with a warning. The man foolishly transgresses the rules, not once, but twice, wrongly expecting his godfather to be lenient.
 Lesson: You can't cheat death.

The Juniper Tree: A cruel woman murders her stepson and then cooks and feeds him to the boy's father. She thinks she has gotten away with her crime, not knowing that a phoenix has risen from the child's grave and is telling everyone what happened.
 Lesson: You can't hide your evil deeds.

The Robber Bridegroom: Although her betrothed is handsome and rich, the beautiful young miller's daughter does not trust him. She secretly visits his cottage, deep in the forest, where she learns he is even worse than she imagined—he is part of a band of murderous cannibals.
 Lesson: Trust your instincts—don't judge someone by how they appear.

Snow White: An evil queen's efforts to kill Snow White are thwarted, time and again. Despite the queen's clever attempts, those who meet Snow are won over by the girl's gentle spirit and end up rescuing her from certain death.
 Lesson: A pure and innocent heart will conquer evil.

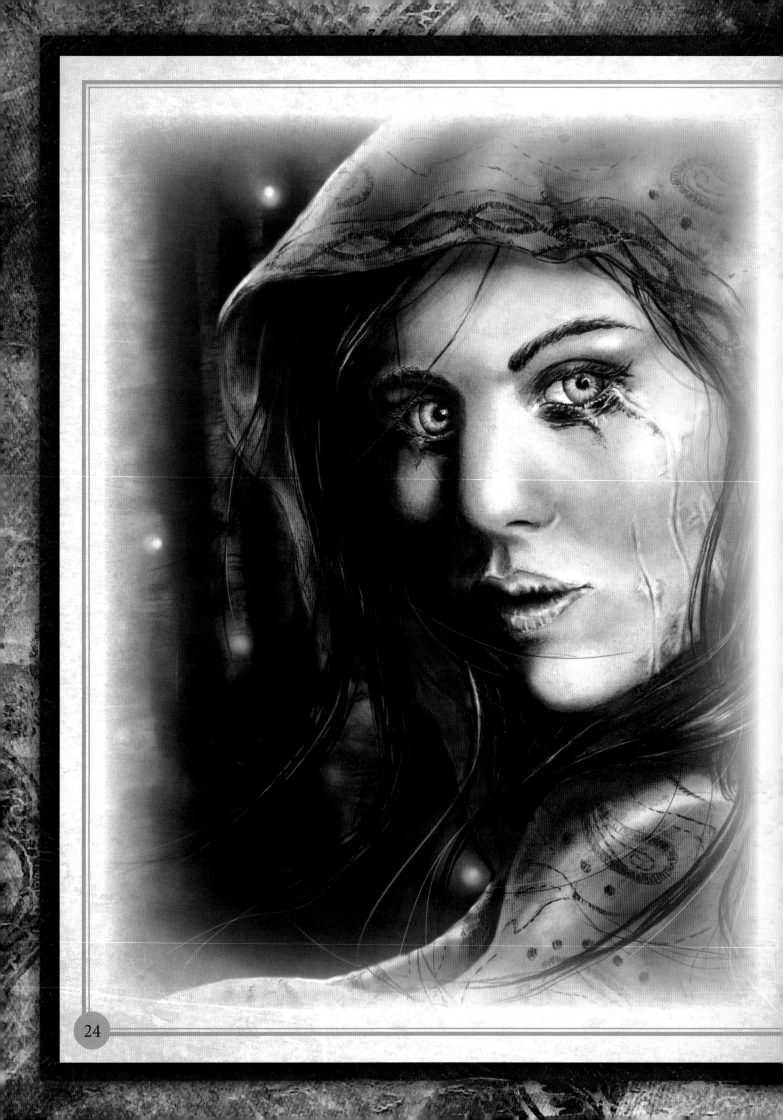

Chapter 2

PROTAGONISTS

A curse of sleep, a dangerous forest, a poisonous apple, a cruel stepmother, a lost glass slipper, and a high tower—these are the obstacles that prevent a Grimm protagonist from reaching her goal. She must battle dangerous creatures, such as talking wolves; befriend benevolent creatures, such as talking birds; and fend off enchantresses who possess magical powers. Often, she's a mere child when the story begins, and the whole world is against her. Still, somehow, against all odds, she manages to succeed—even if it takes her a hundred years.

This is the world of the Grimm fairy tale, where the weak, helpless, and downtrodden find the strength to battle the evil forces that come against them. Good either triumphs in these stories or evil is punished. Sometimes both. But ultimately, a lesson is learned.

Red Riding Hood was only a child when she lost her life because she disobeyed her mother, who warned her to stay on the path and not wander through the woods. But Red fell prey to a wicked wolf's lies, and she was later eaten. In a normal story, this might have been the end. Not so in a Grimm tale, where the innocent dead are often resurrected and given another chance. (Fortunately for Red, a woodsman rescued her from the belly of the wolf.) Snow White's problems began when she was seven years old and a magic looking glass revealed her to be more beautiful than the Queen. Later in the story, the young girl naively and repeatedly trusts those who seek to harm her. Snow ultimately survives each of the Queen's attempts to poison her—but it's not because of the girl's wit or strength. Each time she is rescued by someone who loves her.

Innocence, love, wisdom, and obedience are the unusual weapons used by the Grimm Brothers' protagonists. These traits enable the characters to win the battle against darkness. And the fact that the protagonists make mistakes but never lose hope, is why we love them so much.

Red Riding Hood

After a deadly encounter with a ravenous wolf, Red Riding Hood learned two valuable lessons: Don't go for a walk in the woods alone, and don't talk to strangers—especially if those strangers look like they want to eat you for lunch. Now, battle-scarred and wary, Red knows what to do when a second wolf comes knocking on Grandma's door. Fight!

STEP 1
I use several reference photos to work out a sketch. Then I begin filling in the shadows with lightly placed soft charcoal (2B) and a cotton swab. I begin where the shadows are darkest and build layers of charcoal to fill them in with deep enough shades.

STEP 2
I keep building up the shadows and contours of the face. Pay attention to the fine dips and lines around the nose, eyes, and mouth—this is where the realistic look begins to show. I pay close attention to the details around the eyes, filling them in more to give the drawing life.

ARTIST'S TIP
The more your swab fills with charcoal, the less you'll need the pencil. Instead, start filling in soft curves with the swab—this will help give your finished drawing a smoother look.

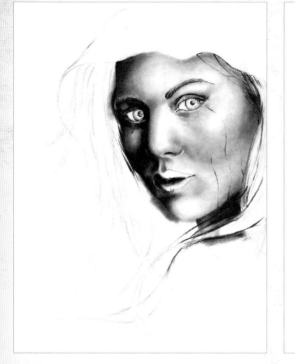

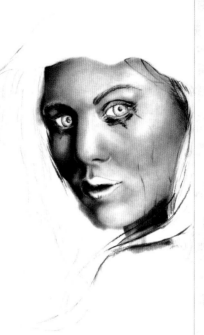

STEP 3

I smooth the charcoal with a clean cotton swab and finish shading the facial features. Charcoal smudges easily, so I protect the art by placing a tissue under my drawing hand to cover the parts I'm not working on. I add thin light spots in the shadowed lashes with a white charcoal pencil. Then I add in scar lines on the side of the face.

STEP 4

Time for some color. I begin by rubbing a cotton swab on a flesh-colored pastel stick. Then I sweep the swab over the face to place the first layer. I don't apply much flesh color—I am aiming for a pasty, moonstruck look. I also want her eyes to be the focal point. I add in the black makeup with a sharp 4B charcoal pencil. Then I soften the eyelids with a cotton swab.

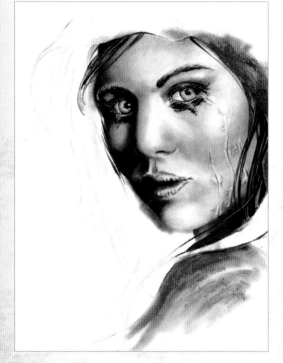

STEP 5

I use pastel pencils to color the eyes and lips and a deep red pastel stick to layer in the red of the cape. I add some pink pastel pencil in the eyes (veins and rims) and the scars to give them a more raw, fleshy look. I use a small smudge stick to spread and blend my pastel pencil marks as needed in the fine details. When coloring the eyes, pay attention to the way real eyes appear—how an iris is full of its own lines and shapes. Look at your own iris in a mirror and study how the colors of an eye are actually placed—the variety of color may surprise you!

ARTIST'S TIP

Light gives your drawing pop—watch the light areas closely, and try to keep them clean—charcoal is very difficult to erase once placed.

STEP 6

Now I have a well-developed face, but the devil is in the details! I decide to give the fabric of her hood its own personality and help it stand out even more. I add a simple pattern, allowing it to move with the shape and flow of the fabric.

STEP 7

I add red to the cape, leaving white paper in some areas to show light. I also begin to shape the hair around the face. At this point any mistakes in the face should become apparent and be fixed. Once I'm happy with the shapes and shadows of the face, I add even more details to the eyes—a bit more yellow and a spot or two of burnt umber. I smooth out the texture of the lips and lighten them to blend in more with the face. Check for spots of light that might have been covered over by accident and use your kneaded eraser to clean them up.

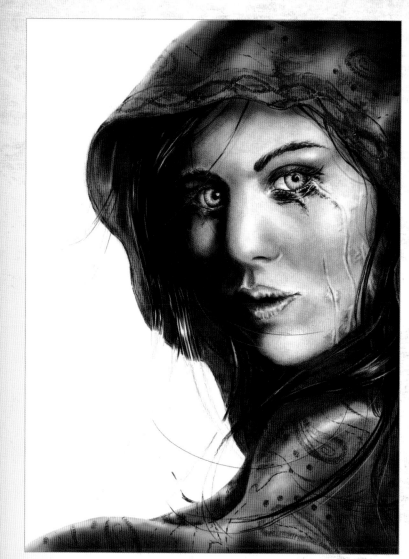

STEP 8

I layer in more color over the cape with a combination of pastel pencil and stick. I also lay down the hair more firmly, differing the thicknesses of the strands in spots to help achieve a realistic look. Real hair is never neat and tidy—let a few wild strands fly across the face. I go over the cape details, varying the shades of black and adding in more spots of deeper red around some of the pattern for depth. I add in more hair around the face and inside the cape. I leave the hair outside the cape alone for now because I still need to add a background.

ARTIST'S TIP

The more you smudge and go over an area in your drawing, the more texture you add to the piece—don't be afraid to play!

STEP 9

If you decide to work by hand you can begin laying down the background of trees into the main drawing. I create a separate drawing for my trees, varying the sizes and shapes to add depth. I keep the shadows very dark. I add texture to the trees with lines and smudges as I go, layering charcoal and spreading it with a cotton swab. I scan my trees drawing into Photoshop® and create a new layer behind Red Riding Hood.

DETAIL

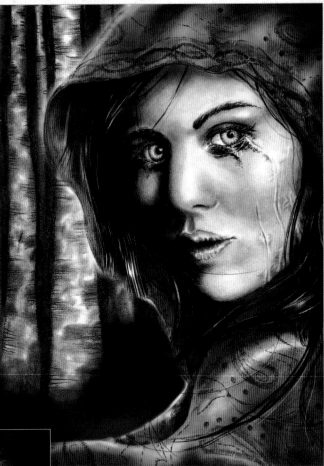

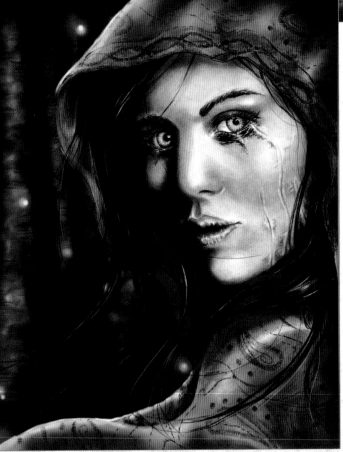

STEP 10

I add more shadows to the trees and the suggestion of a wolf silhouette emerging from them. I shape the wispy hair more. Then I add in some faerie lights to deepen the fantasy feel and bring some color into the dark background. The greenish-yellow of the light also reflects in her hair and helps the eyes stand out even more.

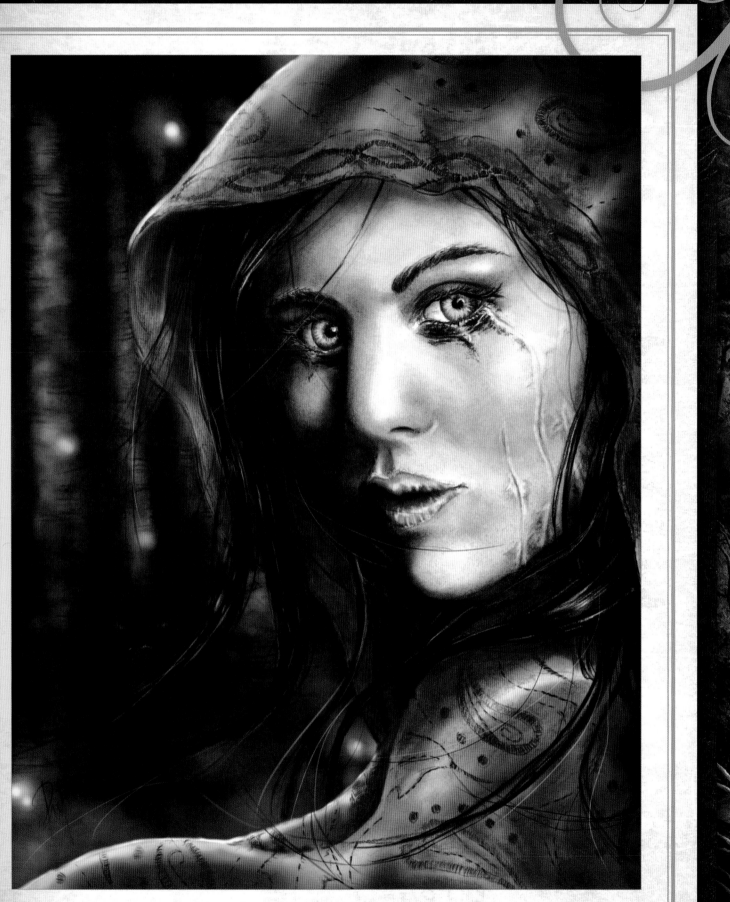

STEP 11

If you're working by hand, use red pastel pencil for the wolf eyes on the black background and a white charcoal pencil for the light reflecting off the tip of the nose—these are the only parts of the beast visible through the fog. I add the red eyes and nose reflection in Photoshop, using the brush tool. Double check for unwanted smudging and then sign your new masterpiece!

Cinderella

Sneaking off to a ball, wearing a gown given to her by a magical bird, Cinderella never expected to meet her true love. But one dance with the prince and they were both smitten. But he still had to outsmart Cinder's wicked stepsisters, both willing to cut off toes and heels to squeeze into the golden slipper left behind. Fortunately, blood dripping from the shoe revealed their lie, and the prince was finally able to find his true love.

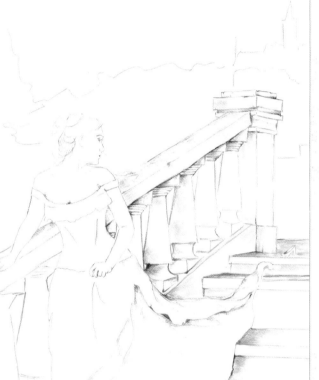

STEP 1

I work out several sketches and then finalize my lines. I begin shading in the base shadows on the stone with a 2B pencil. Beginning with these shadow areas is a good way to warm up before jumping into the details.

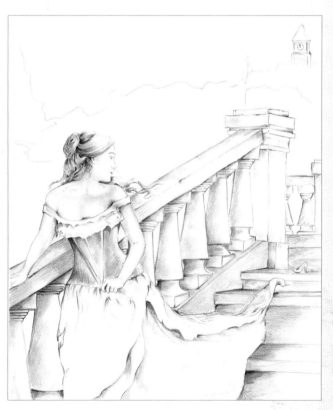

STEP 2

I layer in shading for Cinderella's hair and dress, as well as the shadows on her upper body. It's helpful to reference photographs of fabric and hair as you work to ensure you achieve accurate values and texture.

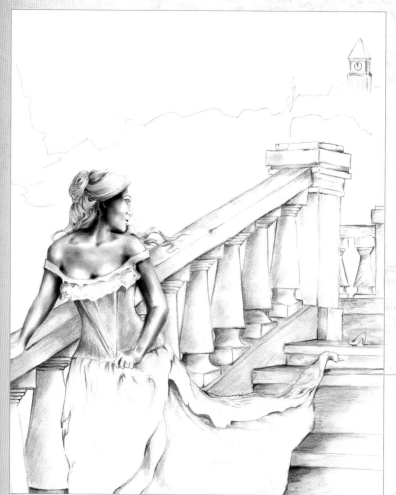

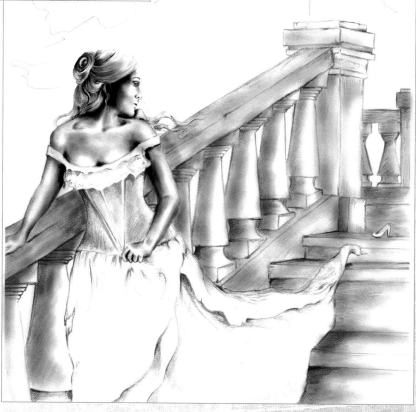

STEP 3

Now that I have a good foundation, I start filling in the stronger shadows. I use a 4B to darken shadow areas around her hairline, neck, and arms.

STEP 4

I go back to shading the stone staircase with a 2B pencil. I also add more shading to her hair and her face. The light is coming from behind her, so the whitest part of her face will be her brow and the tip of her nose. I leave these areas white.

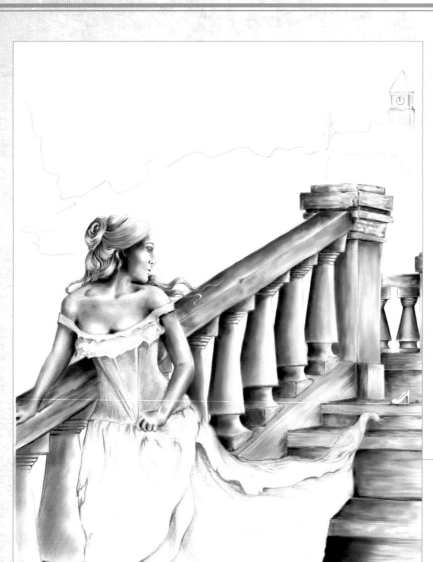

STEP 5

I start adding more detail and texture to the stone. I use a 4B pencil to shade the darkest areas around her dress, as well as along the shadowed sides of the columns and bannister. I draw in the ridges at the top of each column. As I work, I add small nicks and creases to achieve a realistic feel.

STEP 6

I turn my attention to the ball gown, which is beginning its transformation after midnight from a silk dream to a ratty, soot-coated mess. I use a 9B pencil to shade in the bodice, shading around the boning in the front and using less pressure in the lighter areas. I also use this pencil to shade the dark shadows on the top of the lower half of the skirt. I use a 2B pencil to shade the folds on the top of the skirt and press harder to shade the folds and ripples in the bottom half.

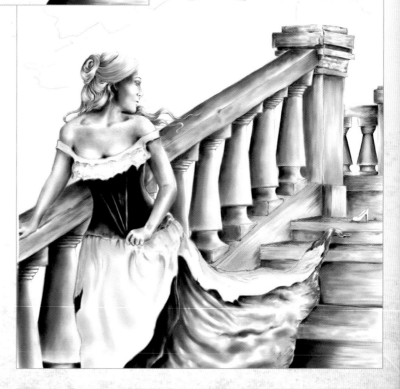

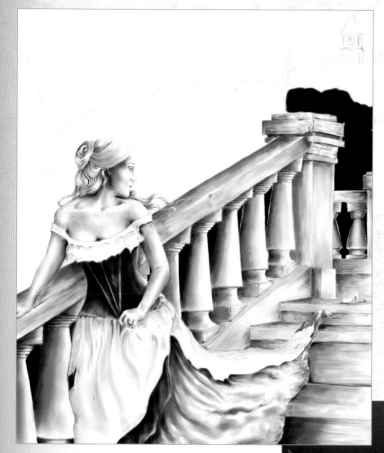

STEP 7 I begin filling the background with black pastel. You can also scan your drawing into a computer and digitally paint at this point.

STEP 8
I finish filling in the background, and then I begin to build up the hills and the midnight sky with white and gray pastels. You can use white charcoal or leave white spots in the background and use a cotton swab to pull color in, blending dark to light.

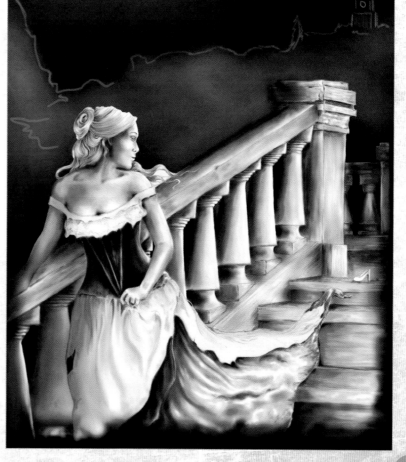

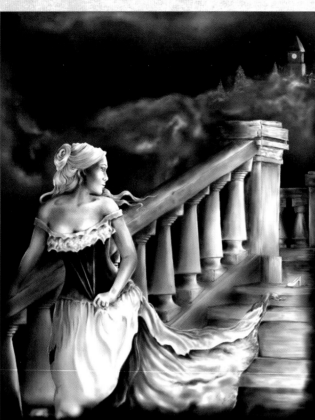

STEP 9

I fill in and soften the fog and clouds using white pastel and a cotton swab. Then I fill in the small details for the clock at the top of the hill, which is striking midnight of course. To draw some attention to it, I add more white to the side facing the light source to give it a glow. I also draw in some trees. Then I add a few stars dotting the sky.

STEP 10

I reinforce a dark border around the entire drawing. Then I draw attention to the glass slipper by creating a little bit of a haze around the shoe and adding some magic sparkles.

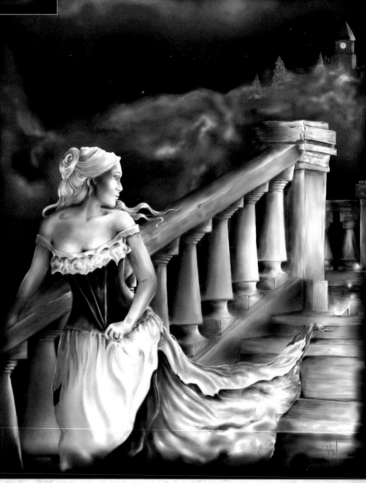

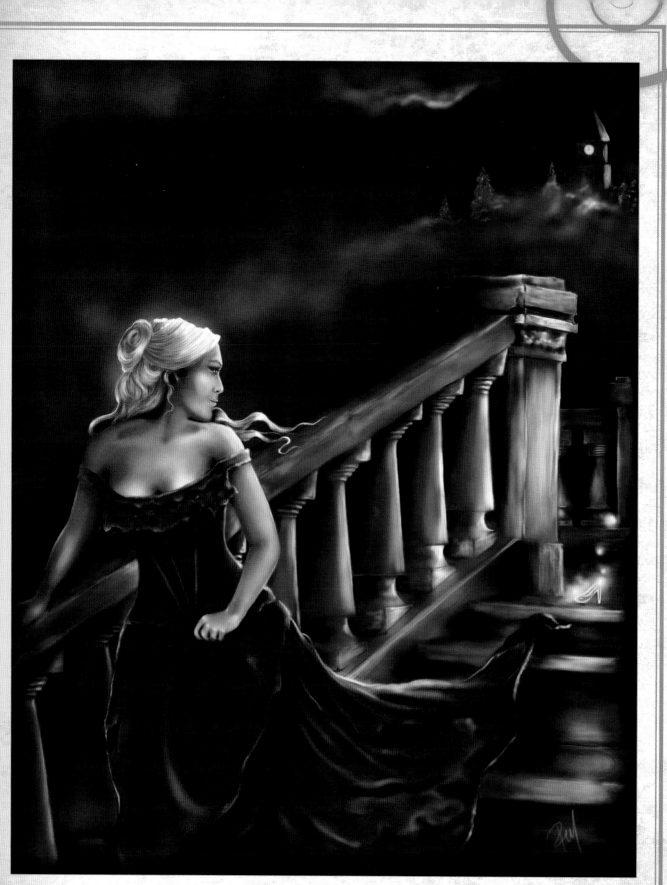

STEP 11

If you'd like to keep going and add color, there are several directions you can go. To keep with the midnight theme, I used a series of blues and purples, with a touch of green for the stone. Using color cuts back on the "gray" feeling of the piece and helps the light have more impact. It also allows for the majesty of the moment to shine through!

Rapunzel

Trapped in a high tower, with no Wi-Fi or social media, Rapunzel still managed to snag a hot prince with her long golden tresses. When her stepmother discovered that Rapunzel was "in a family way," she exiled the girl to the desert, and the prince was blinded by thorns. Despite their star-crossed beginning, the blind prince managed to find Rapunzel and their twin children, perhaps giving new meaning to the phrase "true love."

▶ STEP 1
I start with a detailed sketch, which is a little more whimsical than what I want my final drawing to be, but it helps me decide where I want to take the artwork.

STEP 2
I start my line drawing of Rapunzel sitting in the window. I add vines to accent the frame and give the impression that she's been in the tower for a long time.

ARTIST'S TIP
When drawing a black-and-white piece, make sure you determine your values at the beginning of the process and know where your darks, mediums, and lights will be.

STEP 3

I start detailing her face first. I want her to feel as real as possible, so I'll go back to this part often. For now I shade the darkest values.

STEP 4

Next I move on to the dress. The majority of Rapunzel's dress will be darker than her hair and skin, but not as dark as the black, stormy sky I will add later. I shade the dress darker than her face and apply some light shading to the forefront leg. I also start shading the top right of the bench with some hatching and stumping.

STEP 5

I finish shading both legs, leaving white along the tops and bottoms of the shins for reflection. Then I work some more on the dress, shading the parts that peek through her hair and cascade down the bench. I pencil in a delicate pattern on her bodice. Feel free to copy my design, or you can create your own!

STEP 6

I shade the long sleeve of the dress and add more detail and shading. I add darker shading to the creases, lessening the pressure on my pencil as I move out from the folds to achieve dimension. I shade more of the stone bench, blending lightly with a tortillon. I also start working on the hair. Rapunzel is fair-haired so I leave some white space to suggest its golden color.

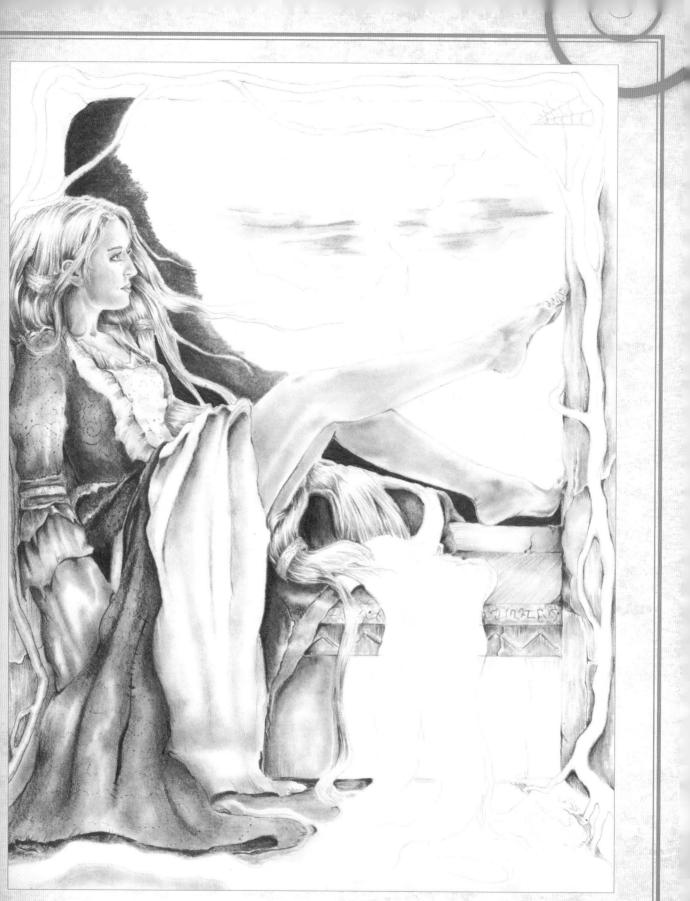

STEP 7

I shade the folds and creases of the lighter dress fabric, leaving most of it white. Then I start darkly shading the sky around her head, hair, and legs. I press firmly to achieve the dark tone that makes Rapunzel pop from the background. Then I begin shading around the vine on the right side of the frame.

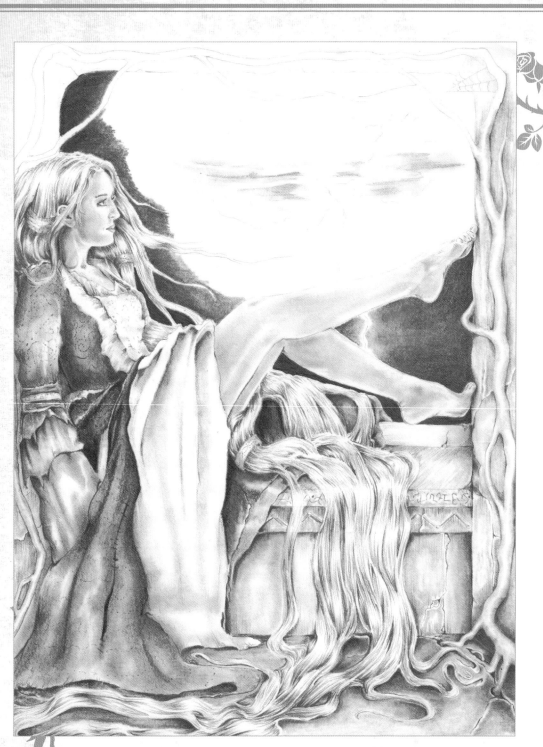

STEP 8

I shade in the dark sky, working around the bolt of lightning. I lift out some graphite with a kneaded eraser around the bolt for a glowing effect. Then I finish the stone bench, adding cracks and fissures to give it an aged appearance. I finish her hair, again leaving a lot of white to make it appear fair and luminous. Don't try to draw each strand of hair. Add curving lines in varying values and lengths, following the shape of the hair. The viewer's eye will fill in the rest! I also shade the stone floor, using darker values around the hair to create shadows.

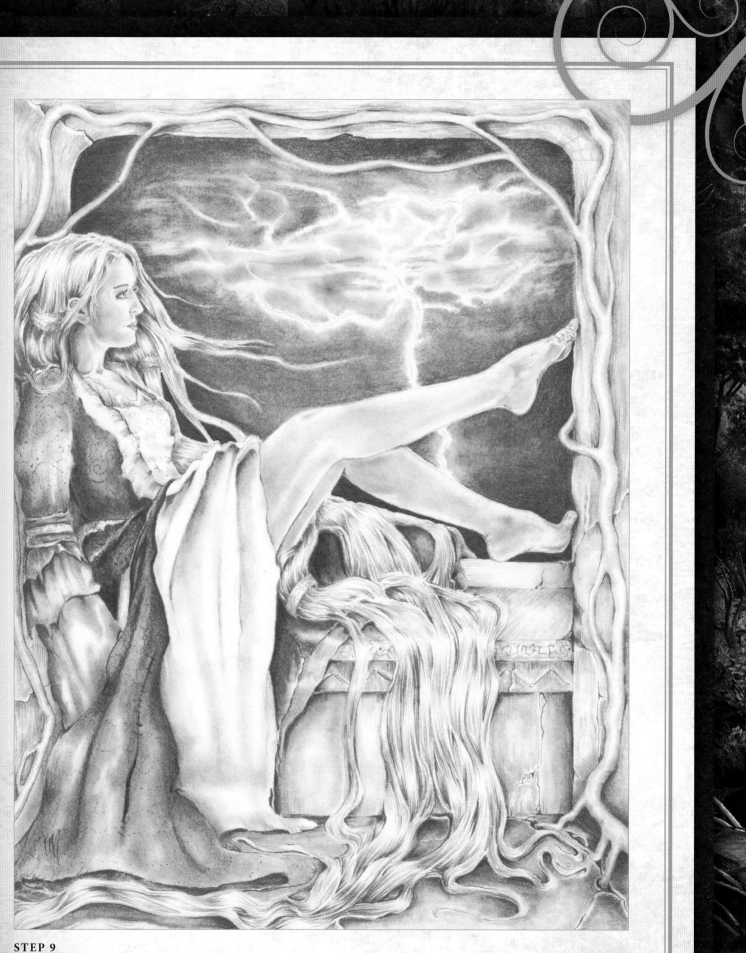

STEP 9

I finish filling in the sky, again shading around the bolts of lightning and leaving some lighter areas. The storm adds energy and adventure to the scene. I finish filling in the frame of stone around the drawing.

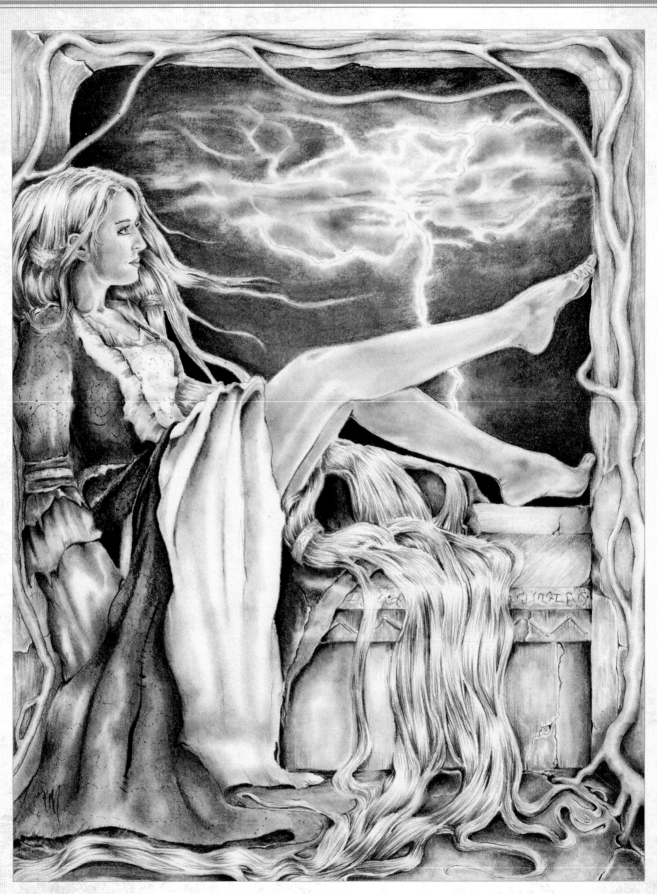

STEP 10

Now that my initial drawing is complete, I want to emphasize light and dark in strong contrast. I start with the outer edges of the sky and shadows behind and around Rapunzel, pushing the value even darker. I also deepen my shadows around the rest of the drawing.

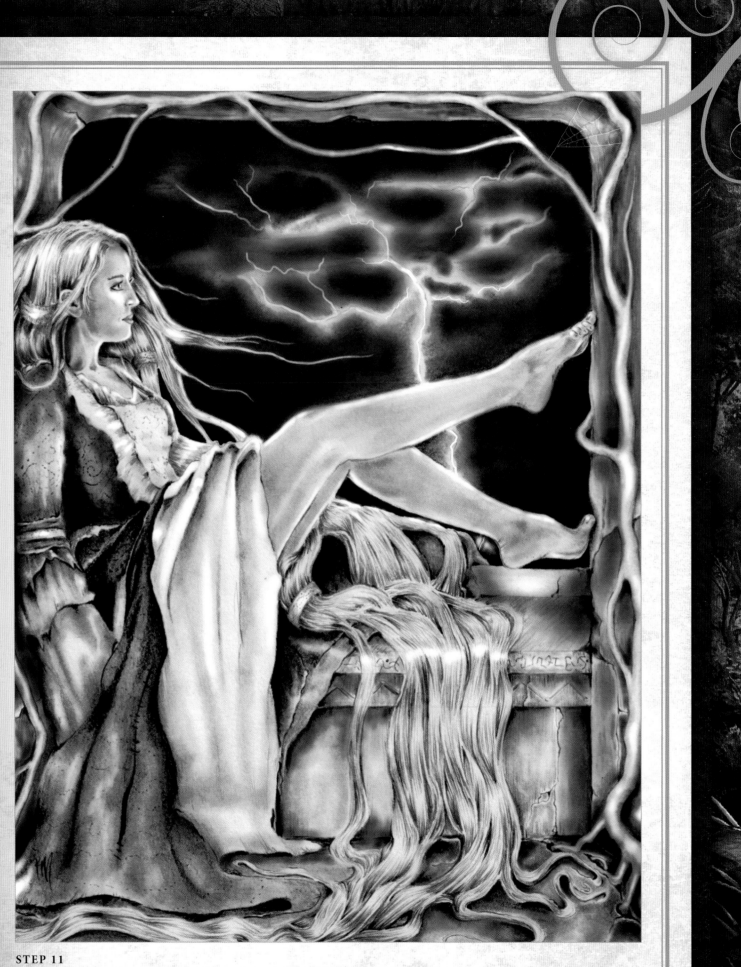

STEP 11
I lightly blend my shading around the frame with a tortillon. You may need to reinforce some of your darks after blending. Then I finish darkening the sky for a dramatic scene.

Snow White

Snow White's innocence and beauty caused her stepmother to try to kill her, a huntsman to save her, and seven dwarfs to shelter her. Three times she naively let her disguised stepmother into her new home, and three times Snow would have died if someone hadn't rescued her. Fortunately, the third rescue was by a prince who then married Snow. It's quite possible he's the one who forced her stepmother to dance in red-hot iron shoes until she died.

▶ STEP 1

I start with a line drawing. I want to portray her innocence and beauty, so I accentuate the eyes and lips. Then I start on the darkest side of her face, shading in the shadow areas. I also shade the lighter shadows on the other side of the face.

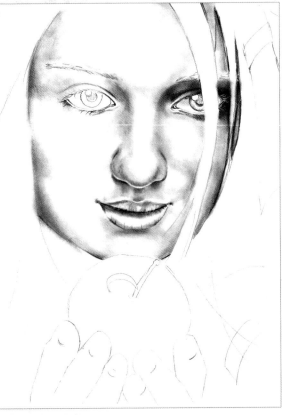

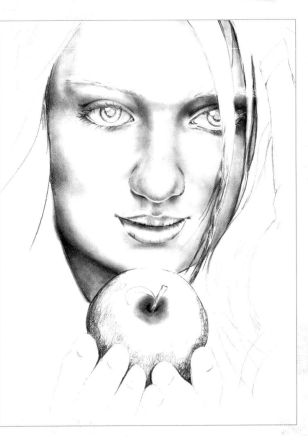

STEP 2

I lightly continue shading the face, careful not to overdo the darks. I start some of the detail on the right eye and shade darkly under the brow bone. I shade the pupil lightly, and I draw tiny, fine lines in the iris radiating toward the center. I also add a light smudge of graphite in the white of the eye.

STEP 3

I add detail to the other eye, keeping the lashes very fine. Then I continue shading across and around the nose and face, including the neck. I start on the apple, using a scribbling motion for texture. I scribble more tightly where the apple meets her hands and more loosely as I move away from the fingers.

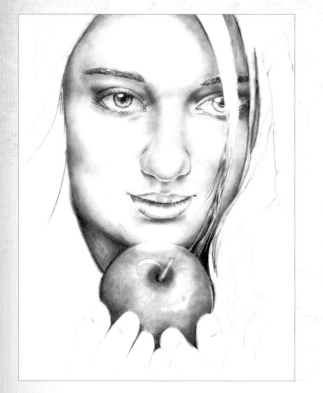

STEP 4

I finish adding texture to the apple. Then I lightly blend to even out the tone. I add fine lines to the eyebrows and another layer of shading on my shadows. I darken the pupils and the dark ring around the iris in the eyes. I also fill in the darkest shadow to the upper right of the apple, behind her hair.

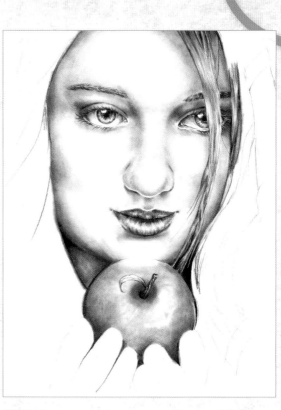

STEP 5

I refine the details in the eye on the dark side of the face. I finish shading the front strands of hair; then I use a cotton swab to blend the shadows on the face and pull some soft tone into some of the highlighted areas. Next I darken her lips and add texture to the apple leaf and stem.

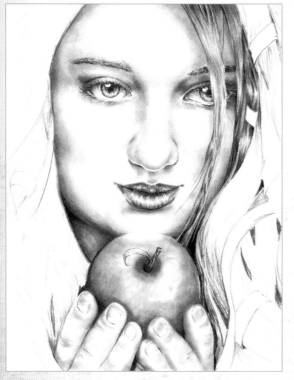

STEP 6

I want to get the texture of her hands as realistic as possible, even though I plan to digitally paint over it later. I take my time shading, adding dark lines for the creases around the knuckles and paying close attention to highlights on the fingers and fingernails.

ARTIST'S TIP

You may find it helpful to use a photo of a model to help you achieve the right shading to bring dimension to the cheekbones, nose, and chin.

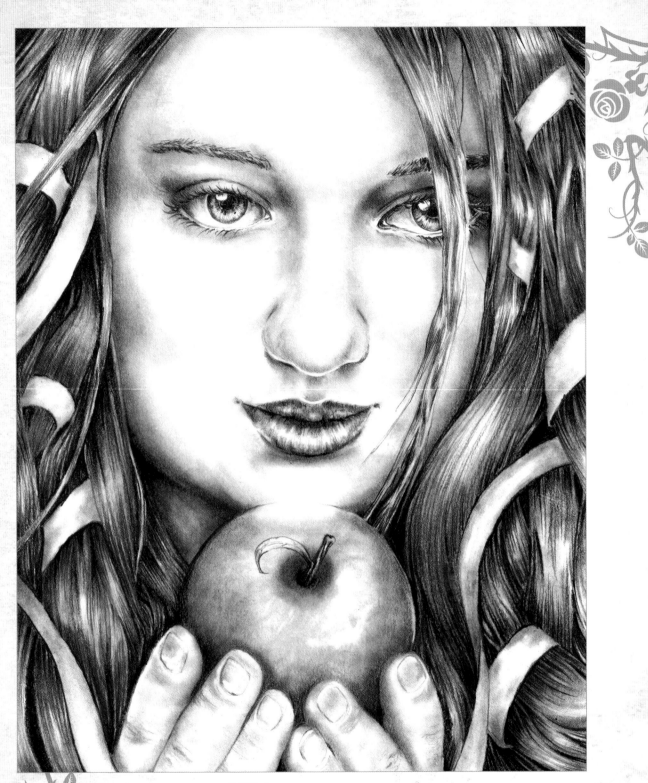

STEP 7

I add movement to the hair and ribbons for visual interest. I look for shapes in the hair and then shade with varying tones and lines that follow the hair's movement. I add very light shading to the interwoven ribbons. If you'd like, you can scan your drawing into Photoshop to paint. Otherwise, your drawing is complete! Darken the darks if you desire more contrast.

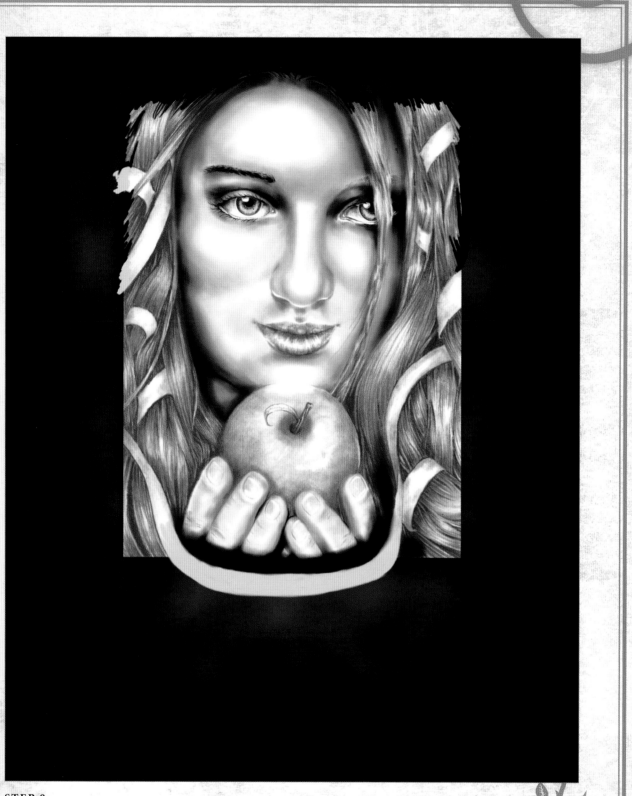

STEP 8

To add color, I scan my drawing. Then I create a base, using the bucket tool to paint the background black. I add a gray tint so that I can see her black hair as I work. I copy and paste the drawing onto the base and add a new layer. On my new layer I start painting the skin tones on her face with the brush tool. Next I go in with some variations of green to paint the eyes. I also use black on the eyelashes and eyebrow. I deepen the shadows of the face using a skin palette I prepared ahead of time. Then I work on the hands, using reference photos and studying the lines and grooves on my own fingers as I tweak and paint.

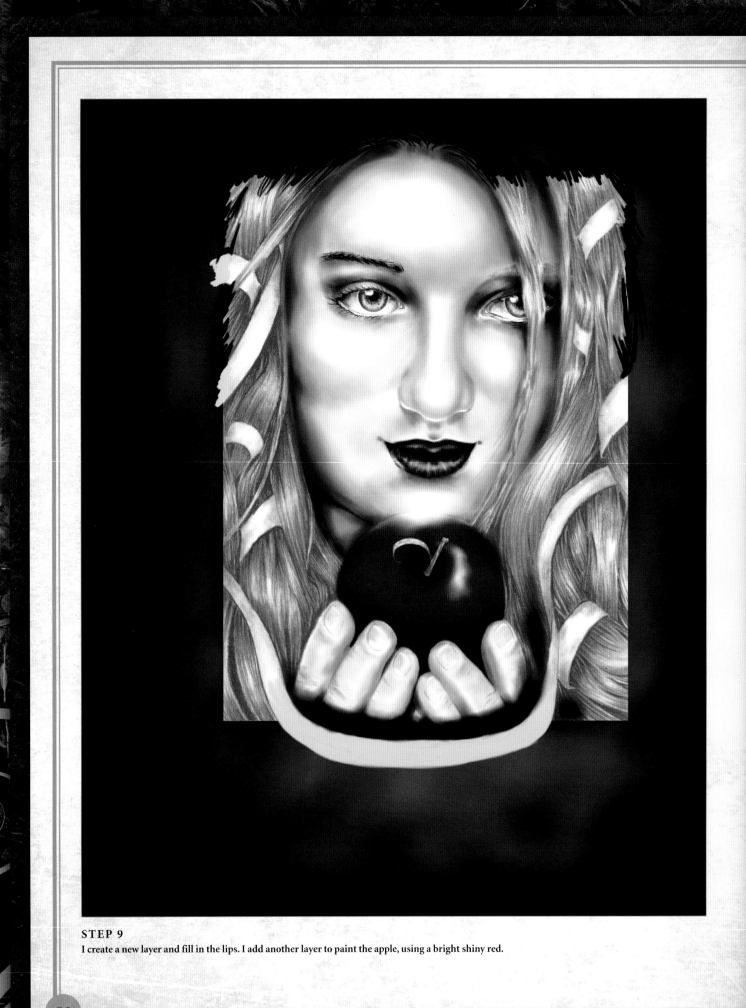

STEP 9
I create a new layer and fill in the lips. I add another layer to paint the apple, using a bright shiny red.

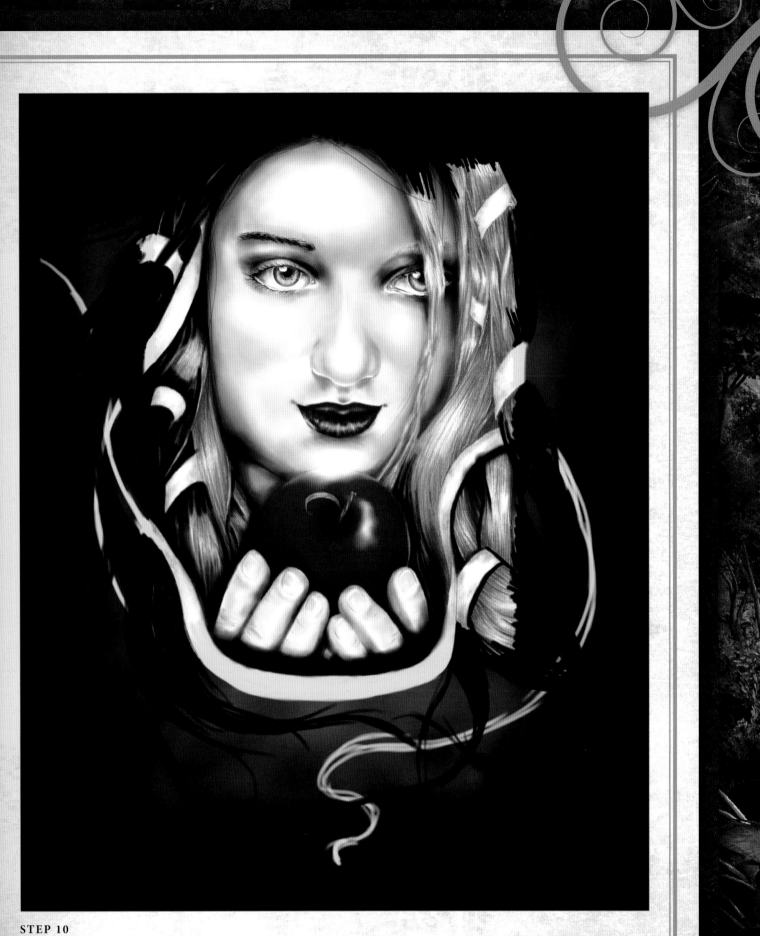

STEP 10

I add a new layer for the hair. Painting the hair is a process. I want to create shape, as well as frame Snow White with it. I draw and erase as needed to start getting perfect symmetry to come through.

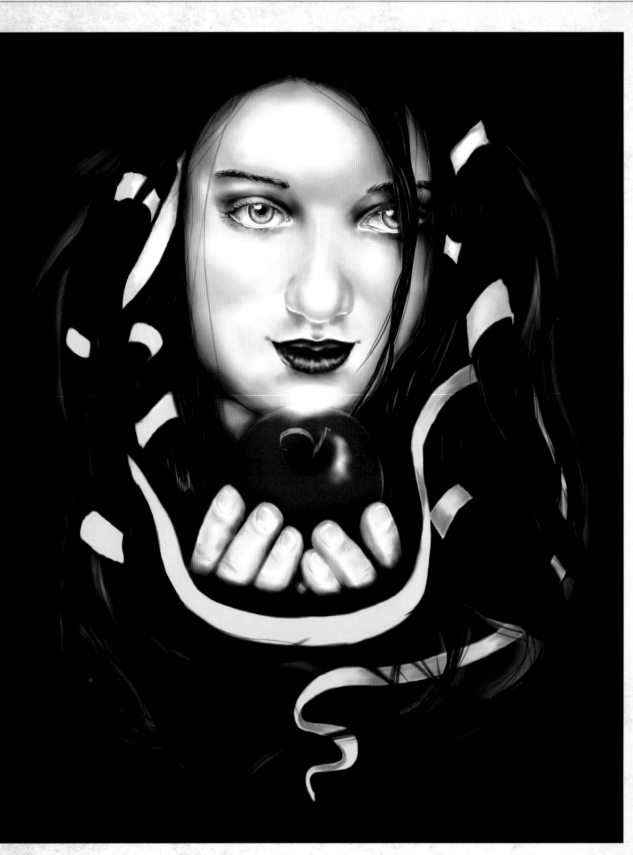

STEP 11
I finish the hair, using the same method. Be patient with this process—it can be time-consuming, but it is worth it. I choose a pale green for the ribbon that will also help highlight her eyes.

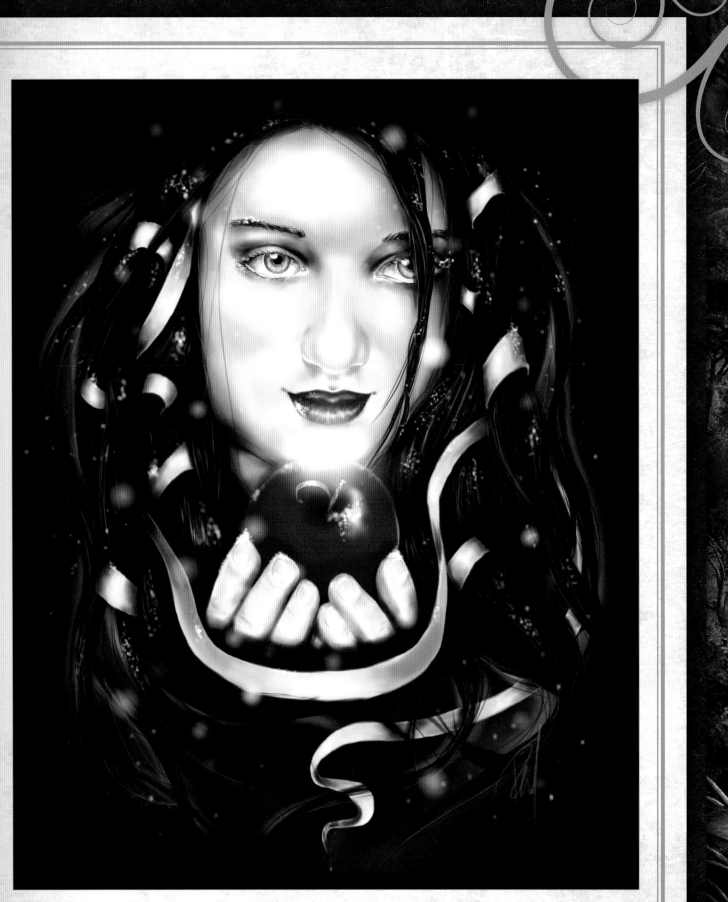

STEP 12

I finish painting the ribbon. Then I place a final layer at the top of the list of the layers panel and name it "snow." Using the brush tool in varying softness and size, I add little snowflakes to the lashes, brows, and her hair. I also add blurred spheres for softly falling snow. Experiment with placing snowflakes in different places. I also add some to her fingertips and on the apple. Lastly, I add a drop of blood at the end of the ribbon—the one reference to death or danger!

Prince Charming

He rescues young maidens from evil queens and helps shut-ins escape from high towers. He dances all night with scullery maids and awakens princesses from slumber with a kiss. This dashing young man is not the boy next door. Prince Charming is every girl's dream-come-true, saving young ladies from a world where they are treated unjustly and giving them a home filled with everlasting love.

▶ STEP 1
In my sketch I focus on the setting of his shoulders and the shape of his jaw. I follow several reference photos to get the look and mechanics of the armor right, especially at the knuckles and shoulders. I use a ruler to draw a straight sword.

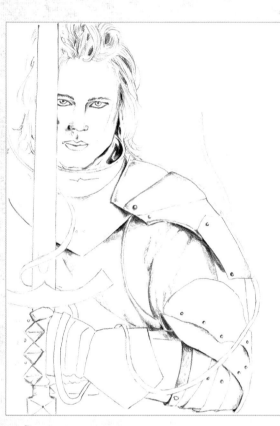

STEP 2
I begin by shading just the edges of the armor and getting a feel for the light and how the metal sits on his body. I start some of the shadows on the face.

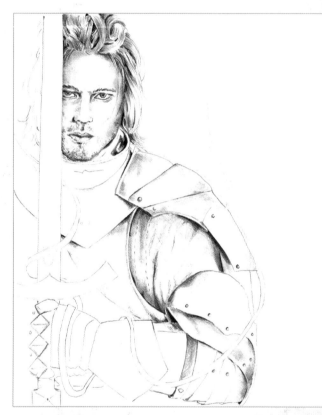

STEP 3
I firm up the lines for the eyes and start filling in the shadows for his jaw and nose. I use small scribbles to create the stubble on his jaw and above his mouth. I also start working on the hair, using linear hatching to create gradations that suggest shadow and areas of light. I add more shading and detail on the armor.

STEP 4

I continue working on the armor clockwise, using a 2B to shade the lighter areas and a 4B for the darker areas. As I shade, I blend gently to create dimension and gradations of light and shadow. I continually refer to my armor reference for accuracy.

STEP 5

It is important to get the shadows of the knuckles right to accent their sharp nature. I use light and dark contrast to give them dimension and hard edges. Then I work on the sword, adding a small design on the hilt and down the blade. I lightly shade the outer edges of the blade and the hilt. I finish shading the hair and add a dark edge along the upper arm and dark shading in the bottom left corner.

STEP 6

I add a final layer of shading and blend the armor to smooth the texture. My pencil drawing is done, so I scan it into the computer to begin painting. If you're working with traditional media, now's the time to pull out your colored pencils or pastels to begin laying down the darker shadows, followed by color.

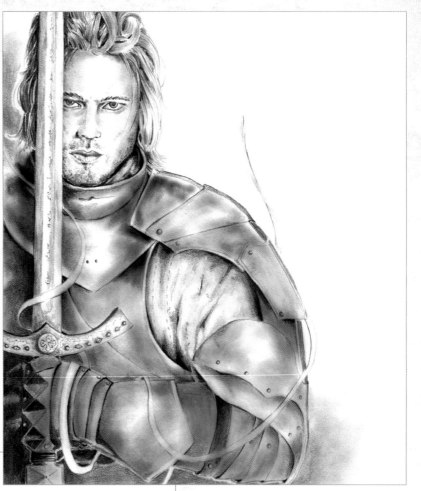

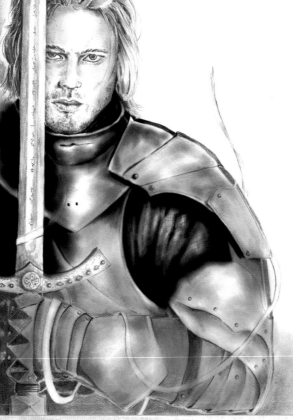

STEP 7

I accent the armor's shine, deepening the shadows allowing for a little more severity in the lines. I give the fabric of the shirt more texture to differentiate it from the armor.

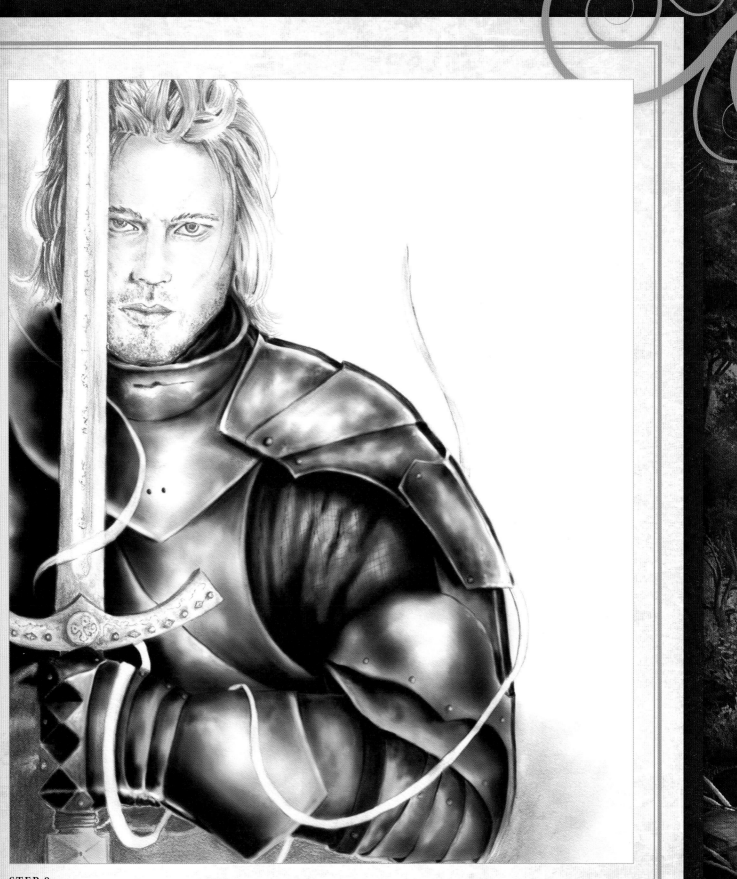

STEP 8

I add more dark shadows to the armor. These deep shadows, along with areas of bright white, give the sheen a more realistic, metallic feel. I also add some dings and marks of wear and tear on the armor.

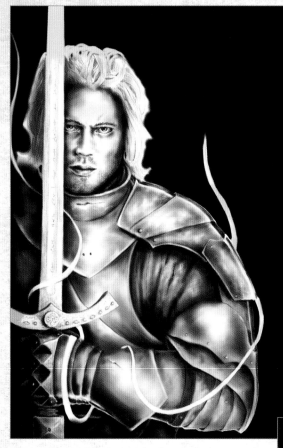

STEP 9

I create a new file in Photoshop and make the background black. Then I add my scanned drawing in a new layer. I add to the stubble, keeping his chin, jaw, and brow firm and masculine. Adding light stubble to the jawline helps accent it. I add some blue to his irises and golden spheres for the highlights. I also define the shadows and highlights on his face.

STEP 10

Now I work on the hair. I want it to look as though he just ran his fingers through it. I go over my line drawing with the brush tool, varying the size of the brush as needed to match my lines. Then I firm up the details on the sword and create reflection to give it shape.

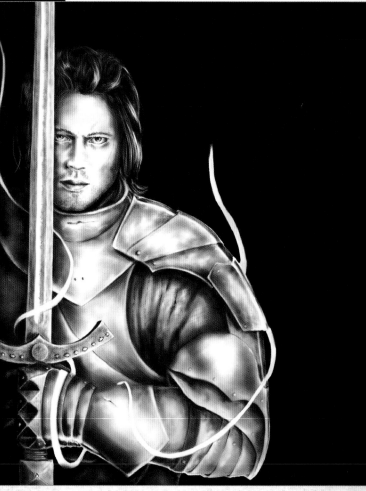

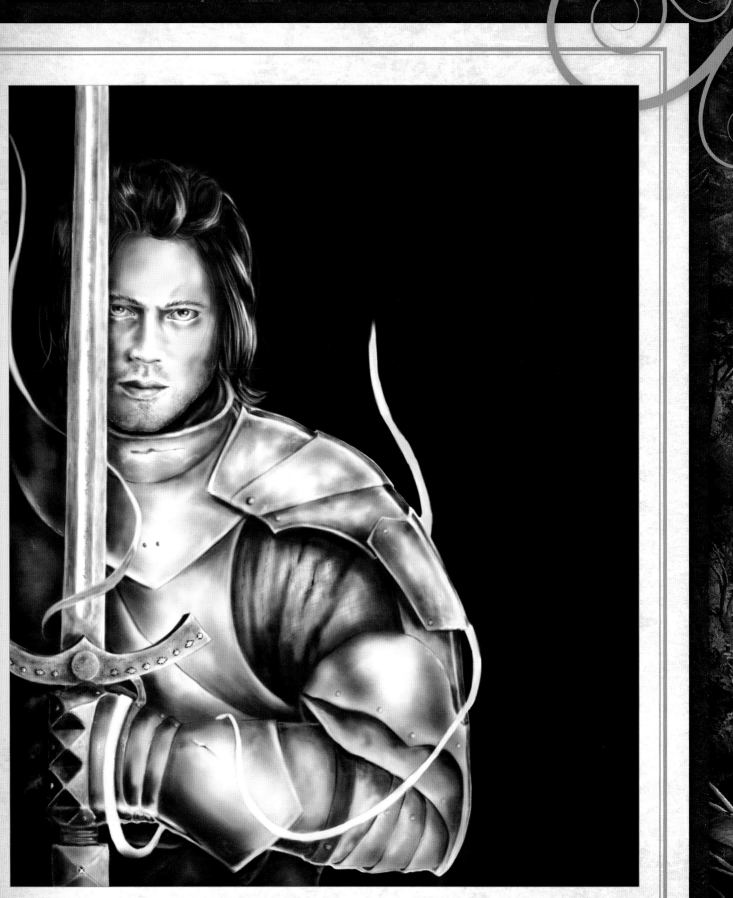

STEP 11
I start to lay down color subtly, with some soft flesh tones on the face. I plan to add a fiery background, so I add some areas of glowing yellow on the armor for reflections from the fire. I also start the blue ribbon that wraps around the sword—a token from his fair maiden!

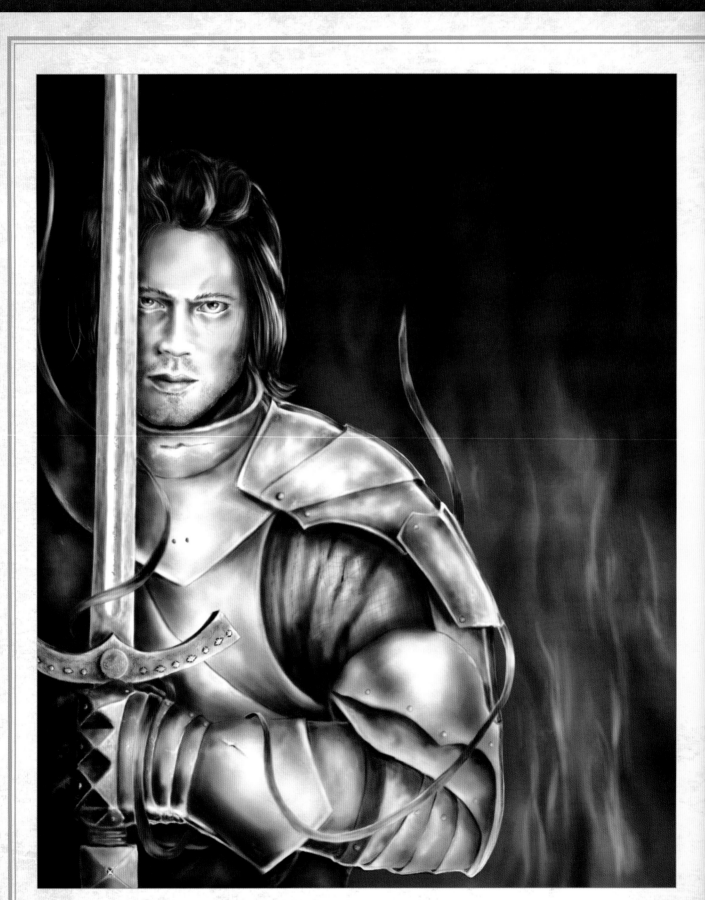

STEP 12

I lay down shapeless smudges of orange in the background to start the flames. Then I use the eraser tool to define shapes. If you're using colored pencil or pastels, map out the fire shapes softly at first; then build on them as you go. I finish the blue ribbon, using a few different shades of blue to create the appearance of flowing fabric. I also add some lighter yellow flames in the fire.

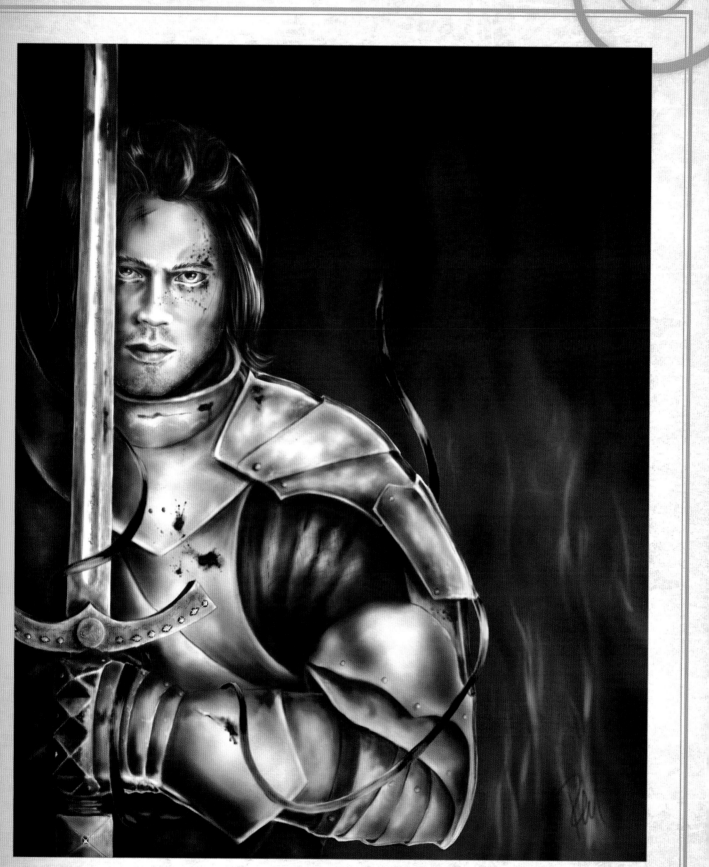

STEP 13

I add blood from his ruthless battle, placing splatters here and there on the armor and his face. I make the blood on his sword more dramatic to suggest he's just vanquished his enemy. I increase the saturation, creating some more dynamic contrast and giving it more "pop."

Briar Rose

The victim of an enchanted curse, princess Briar Rose pricked her finger on a spindle and fell into a deep sleep. For a hundred years, a monstrous hedge of thorns guarded her castle, imprisoning and killing every prince who sought to free her. Finally, one day, the thorny hedge turned to large flowers and let another prince enter unharmed. With one kiss, he woke Briar Rose from her slumber, making all of her dreams to come true.

STEP 1

I begin with a sketch of the scene. Then I start shading the faces with a 2B pencil. The expressions are important—especially hers. I want the emotion to be clear. For the princess, I decide to create a sense of longing, as she awakes from her slumber and sees the face of her prince.

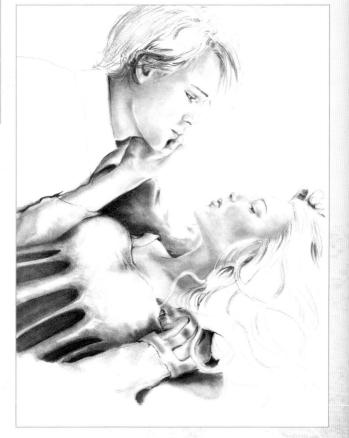

STEP 2

Next I work the clothing. For now, I keep it simple; I'll add in the details later. I focus on highlighting the fabric texture. I work on the shadowed areas on her dress and the prince's arm in the background, using a 4B for the darker areas and gradually lightening my pressure as I move toward lighters areas.

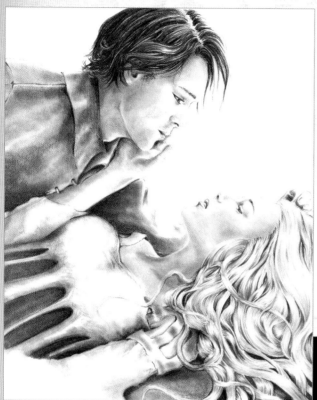

STEP 3

I shade in the rest of the prince's shirt. Then I start working on the hair. Briar Rose's hair is cascading around her in loose, fair curls, so I block in shapes and lines with my 2B to suggest flowing hair, leaving a lot of white space. The prince's hair is darker and a bit mussed. I use my 4B pencil to block in the shapes, leaving some white on the tops for highlights.

STEP 4

I shade the background, keeping in mind the direction of the light. I don't want the piece to be too heavy, so I start with lighter grays, blending as I move out. I use a 9B to fill in the darkest edge of the background.

STEP 5

I scan my drawing and then darken some of the elements using the dodge tool. I start adding in details to the clothing. I create a simple, delicate pattern for the fabric of Briar Rose's dress and use a filter to give it a satin sheen. I loosely draw in a green vine to start the border. I build on the vine border, and then I focus on the shape and placement of flowers and butterflies.

STEP 6

Briar roses are usually pink, so I begin filling in the blossoms with a pale pink. Use reference photos to ensure you create the shape and add shading correctly. The depth of color isn't important right now; I'll focus on that when I am finished with the details. I also start coloring the yellow butterflies.

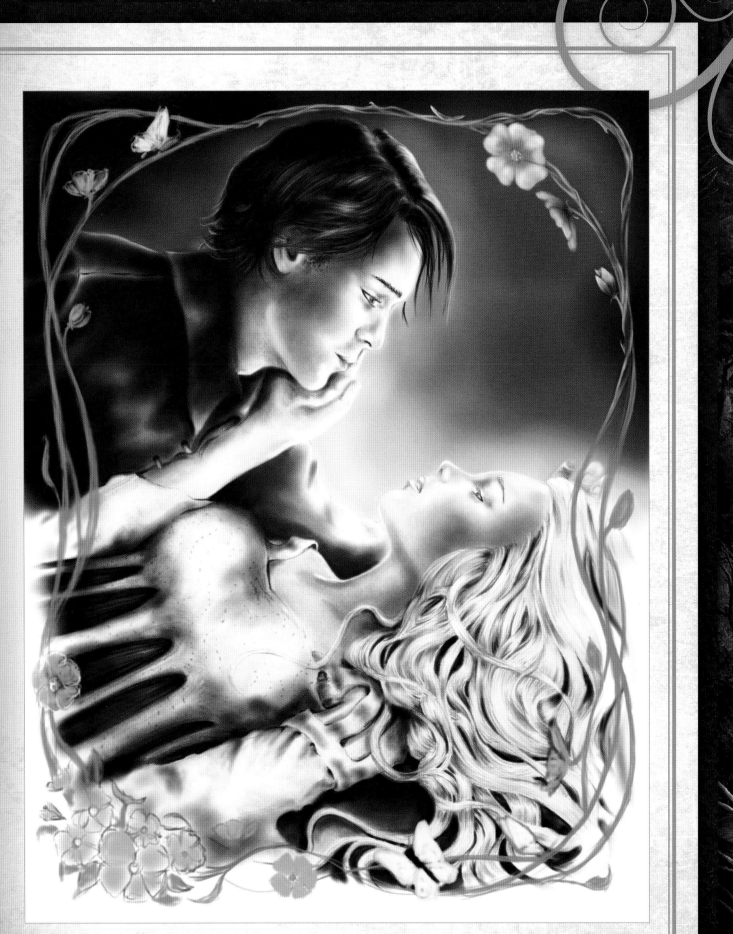

STEP 7

I refine more details on the vine and leaves. Then I start to develop the details on the flowers in the top right, focusing on the openness of the roses and the yellow center speckled with pollen. I add darker pink and gray shading to the visible undersides.

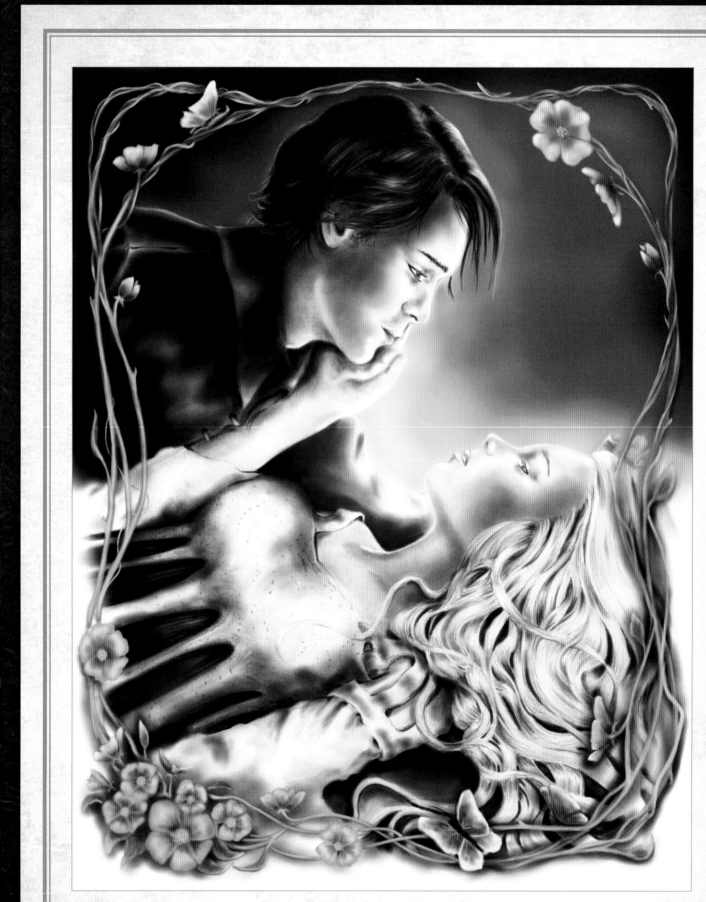

STEP 8
I work my way clockwise around the frame and fill out the details and color on the butterflies and flowers, adding darker shadows to the vine for more depth.

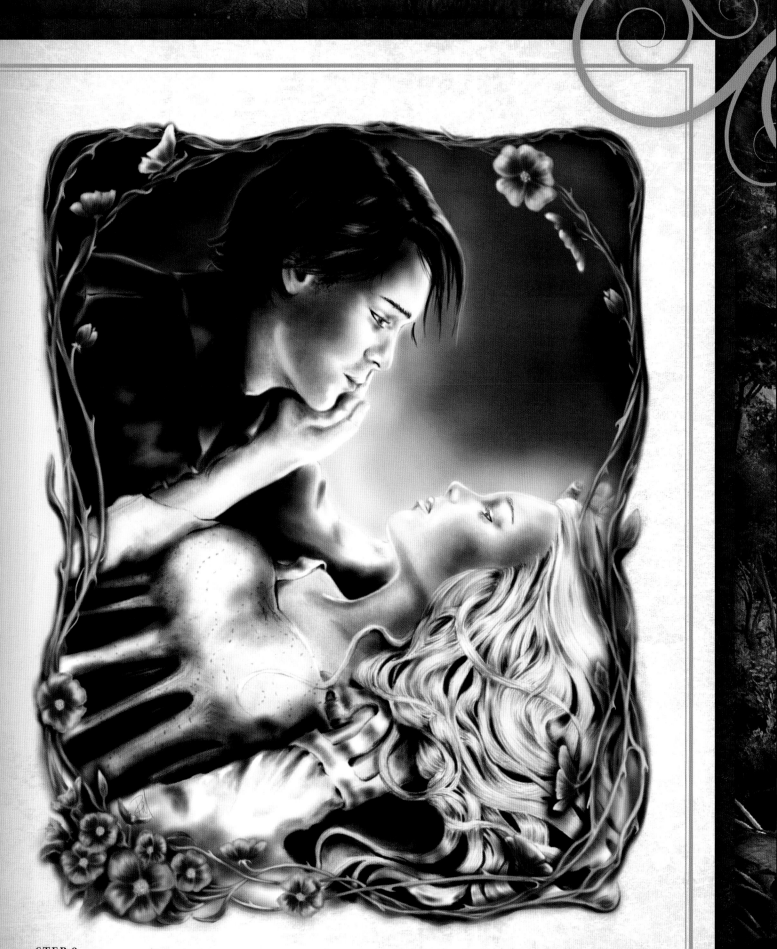

STEP 9

Now I add some thorns and experiment with the saturation to lighten the color. I tint the flowers with a deep red and tint the butterflies to a muted purple. I also remove the largest butterfly. I increase the contrast so my darks and lights make a stronger statement. You can experiment more with your colors to get the look and mood the way you want.

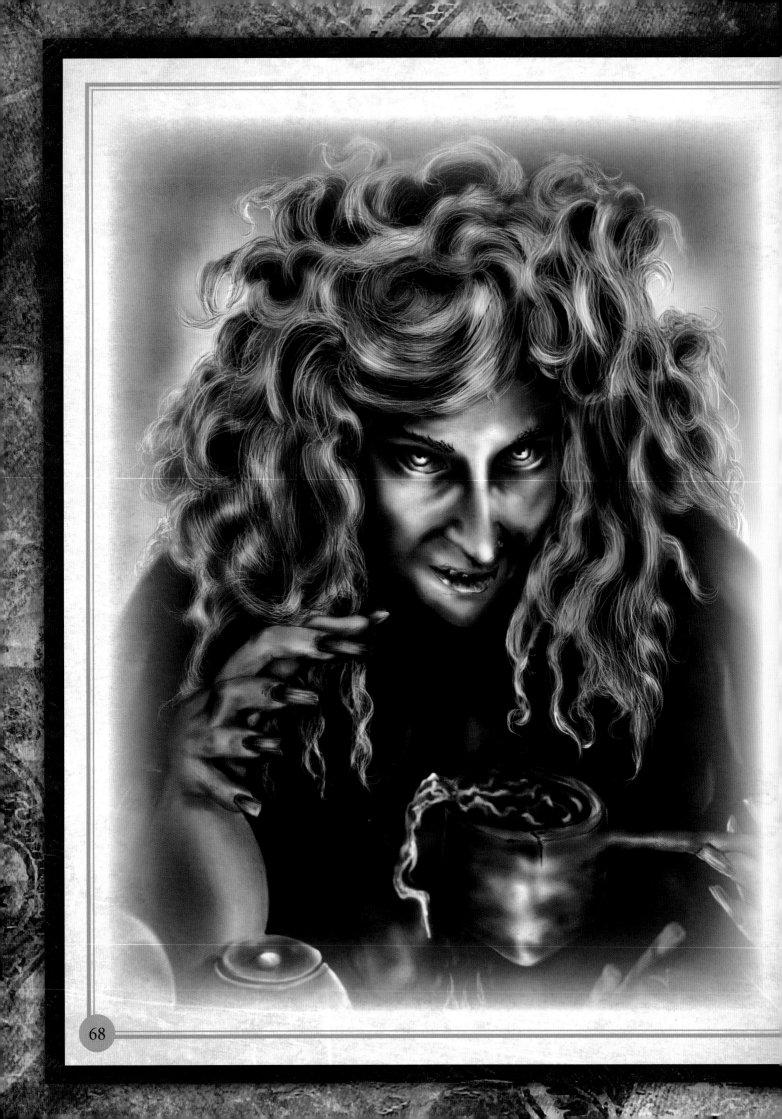

Chapter 3

VILLAINS

In modern stories, the villain dresses in shades of gray and has a tragic backstory.
He was poor, he was abused, he grew up on the streets—he was a tortured soul.
So when he begins a life of dastardly crime, we may feel empathetic.
We may even be secretly rooting for him.

Not so in tales written by the Brothers Grimm.

Here, the bad guys and girls are entirely bad—so evil they give you nightmares.
We never find out how or why the villain got this way, but it doesn't matter.
These are bad guys who don't need to be understood—they need to be stopped.

There's no reason to feel sorry for the cannibalistic witch who lurks inside a house made of candy,
waiting to lure lost children inside. This witch deserves to get baked in her own oven. Likewise,
the robber bridegroom doesn't deserve a bride—not when he plans to murder and devour her. He
deserves a swift and stern trial, which is exactly what he gets. Rumpelstiltskin seems to appear at just
the right moment, offering to help a miller's daughter, but that's exactly what villains do. They follow
a brigand's creed—one that demands cruel payment for acts of kindness. He waits until the girl has
nothing left to trade and then demands her firstborn child, an act that seals his own fate.

An evil queen relentlessly pursues her stepdaughter like prey, sending a huntsman to cut out
Snow White's lung and liver. When that fails, she visits Snow three times, disguised as a
peddler bearing deadly gifts. The evil queen's final penance—dancing in fiery shoes until
she dies—may seem cruel and unusual, but in a tale told by the Brothers Grimm, the
punishment truly fits the crime.

Of all the Grimm villains in this chapter, Godfather Death is perhaps the one we
can understand the most, even though he isn't human. He's honest and forthright,
offering his godson supernatural gifts and fortune—as long as the young man
obeys the rules. The boy knowingly breaks the rules, not once,
but twice, a mistake that costs his life.

It doesn't matter whether you're a villain or protagonist
in a Grimm fairy tale. The final verdict is always the same.
Rules are not meant to be broken.

Godfather Death

A famous, young doctor had the power to heal almost anyone. But he had a secret—his ability came from his godfather, Death, who told him which people could live and which ones must die. Unfortunately, the doctor cheated Death twice, saving first a King and then a beautiful princess. At that point, he forfeited his own life, learning a painful lesson. There are many people you can cheat, but Death is not one of them.

STEP 1
I create a line drawing of an iconic vision of this character. I scan my line drawing, but you can work in pencil. I begin with the face—or skull, in this case. This is the most important part of the drawing. I refer to several reference photos as I work to help me achieve the dark, bonelike result. Notice the tree behind him is cut off, signifying a life cut short.

STEP 2
I begin refining the face, adding shadows to give it form and contour. I want for the skull to suggest that he's looking at his prey. This bad guy has some personality!

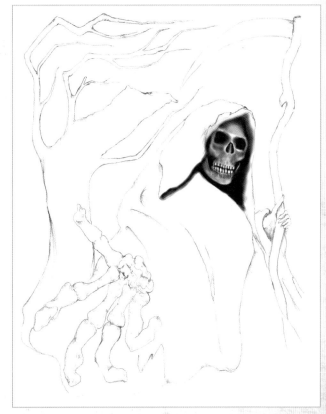

STEP 3

Next I focus on the wooden staff. I use the soft brush tool to create areas of shadow in varying degrees of darkness to give it an aged texture. Then I paint in the deadly blade, using a medium gray tone. I use the dodge tool to barely lighten some areas of reflection.

STEP 4

Next I work on the tree, which has a similar texture as the staff—gnarled and twisted. I also add some darker lines to the scythe blade to give it a little more weight.

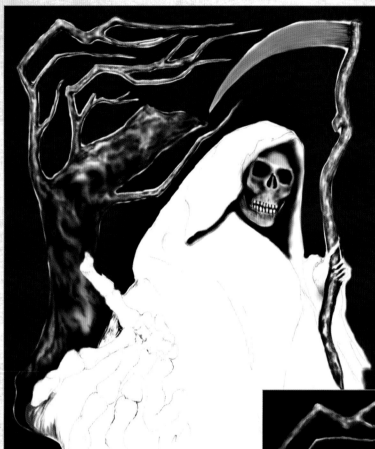

STEP 5

I add in a black background, which adds to the mood of the scene and allows me to better differentiate between the grays.

STEP 6

I begin working on the cloak. This important feature adds movement to the illustration and softens the bony subject. I start with the hood because it helps me shape his face in shadow. I work my way down, using the brush tool in varying sizes and shades of black and gray to suggest flowing fabric. I also add a few highlight lines to the blade.

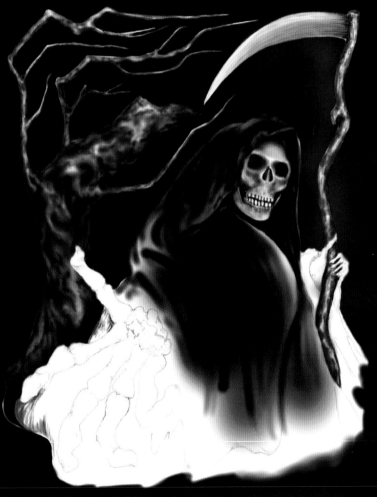

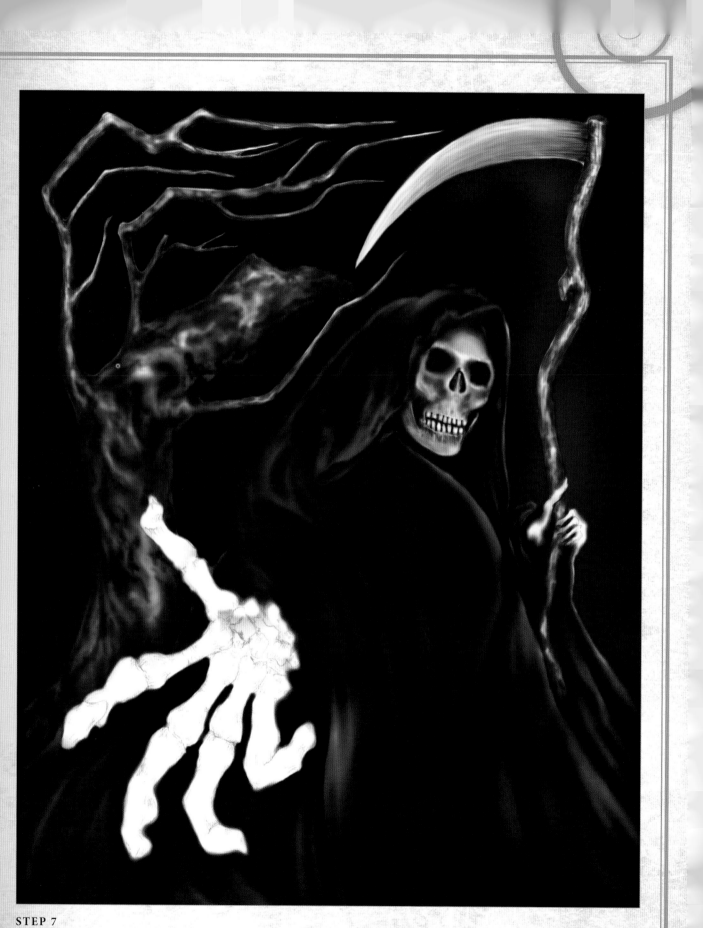

STEP 7

I finish working my way down the cloak, and I soften and blend my lines and strokes to look more like black fabric. I also add in a little red blood on the tree.

STEP 8

Next I experiment with a foggy background, using the brush tool to create the soft look. The fog softens the image some and gives it more depth. I especially like how it makes Godfather Death appear to "glow." I begin the finger bones, using small lines and leaving white space to show reflection.

STEP 9

I continue working on the fingers of the outstretched hand. Most of the drawing is black, so I try to keep these as light as possible, but I want to use enough tone so the difference is not jarring.

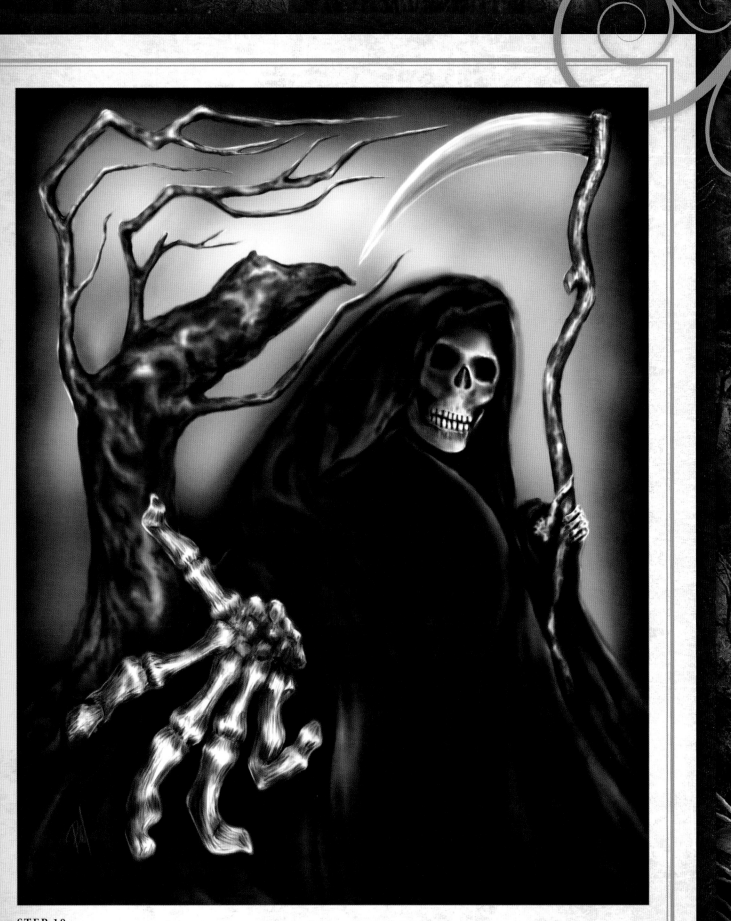

STEP 10

I finish the bony fingers. I decide to erase the blood on the tree and go with a stark black-and-white finish. You can choose to keep it or add even more! You may even want to add a drop of blood at the end of his deadly blade. I make some small tweaks to the fog, and I'm done! Now he's free to roam and collect his souls.

Wicked Witch

Living in a woodland cottage made of bread, sugar, and cake, an old woman seemingly rescued poor Hansel and Gretel, who had been abandoned by their parents. She took the children in, feeding them and giving them shelter. But she did all this because she was really a wicked witch, and she was hungry—for the roasted flesh of tender, young children.

▶ STEP 1

I found a few reference photos to help me get the right feel for my sketch. The wide eyes and pointy chin accentuate her strangeness. Once satisfied with my sketch, I firm up my lines and shapes for my line drawing.

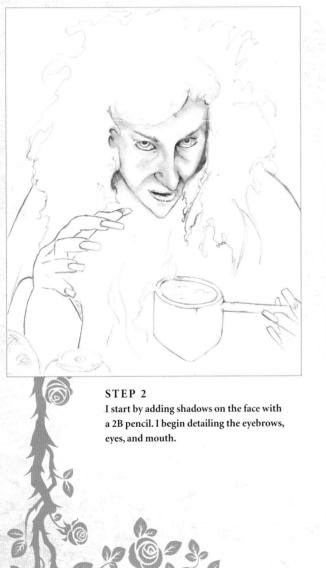

STEP 2

I start by adding shadows on the face with a 2B pencil. I begin detailing the eyebrows, eyes, and mouth.

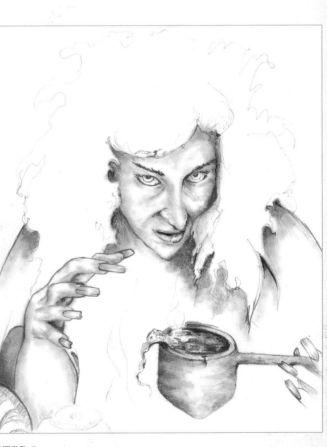

STEP 3

I add more of the darker shadows in the face. Then I turn my attention to her gnarled hands and chipped, brittle nails. I also shade in her arms and the shadows around her hair. I shade the ladle with gradated tone and use a darker pencil for its ominous contents. Laying in these initial shadows first helps give me an idea of what might need to be fixed or re-shaped.

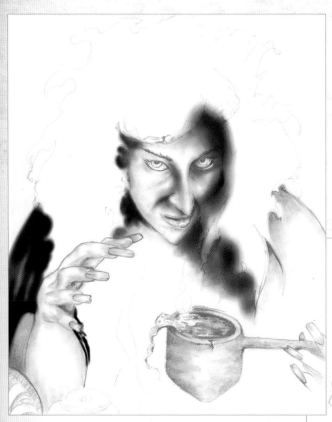

STEP 4
I begin to deepen my initial shadows. You can do this digitally or with charcoal or pastel.

STEP 5
I continue to deepen the face shadows, allowing myself to be generous and keeping in mind the harsh lines I want to create to match her evil nature.

STEP 6
Next I focus on the facial details, keeping in mind the light source and that she's over a fire. I don't add too many wrinkles, because I want to give the illusion of "old beauty."

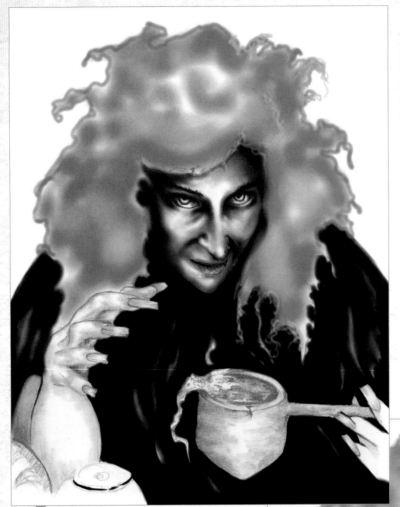

STEP 7
I fill in her cloak and hair with base colors of black and gray. Again, you can choose to do this digitally or with charcoal, pastel, or colored pencil. For now I focus on the shape. I will begin laying in the details later.

STEP 8
I add darker shading to the ladle and to the bubbly potion. Then I begin rendering some of the shading and detail on her hands. I use thin strokes on her nails to create the aged and brittle look. You can use a kneaded eraser or stick eraser to pull out graphite if you need more highlights.

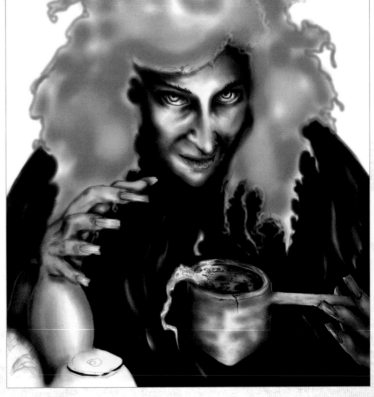

STEP 9

I finish adding detail and shading to her hands. Take your time with the lines in the fingers and the shape of each crease. This is a focal point, and you want them as dynamic as possible. I also go back to the hair and add shadow shapes with black. I start to render the hair more on the right side, making wispy, white strands. Then I add a little bit of color—a hint of red in the whites of her eyes, some reflected firelight on the ladle, and the red apple in the corner.

STEP 10

I add in a black background and a glowing aura behind her. You can use white charcoal or pastel to achieve this light. Then I add more details to the hair. I use messy lines so it looks frizzy and tangled. I add some red to the candy in the corner and the peppermint sticks by the apple, and I refine the shape of the pot.

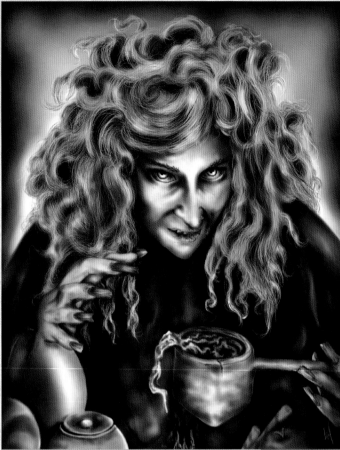

STEP 11
I focus on finishing the hair. This is most arduous part of the illustration. As you work, take a break now and then to either walk away for a bit, or tweak other details throughout the drawing.

STEP 12
I scan the piece into my computer and add some color. You can also use pastels and a cotton swab to overlay tint. I choose green for the skin, to give her an even more rotten vibe. I add more red to her bloodshot eyes and a hint of gold to the irises. Then I add yellow and red in the background to give it a fiery pop.

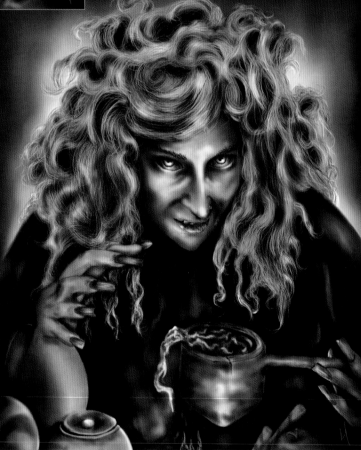

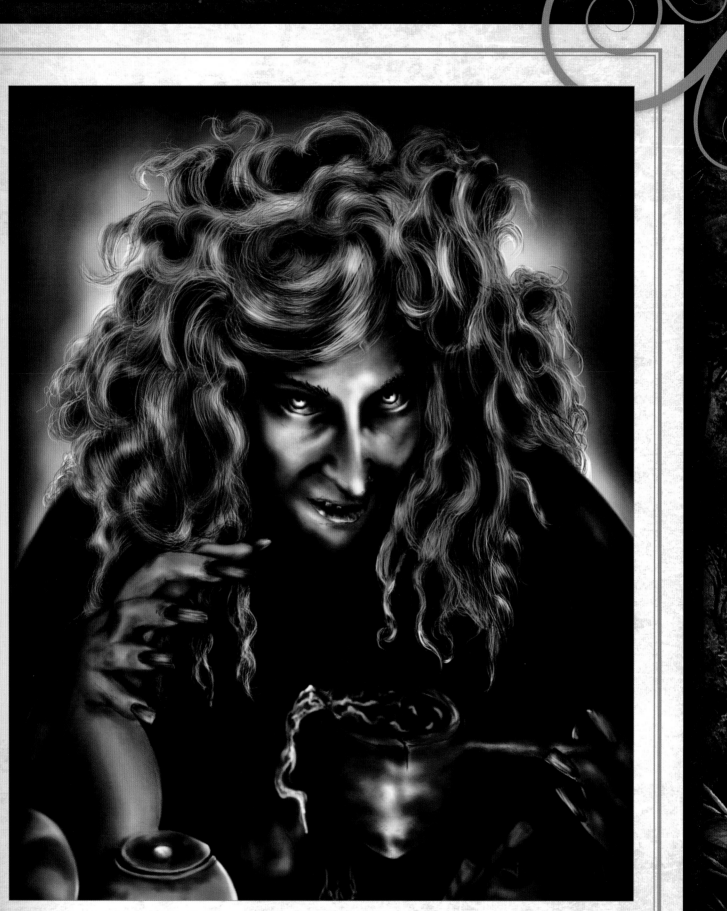

STEP 13

I brighten my color tones and deepen my shadows for even more emphasis, using image adjustment levels in Photoshop. If you are working with pastels or colored pencils, continue building layers until you achieve the depth and vibrancy you desire.

Rumpelstiltskin

Sometimes villains can be mistaken for saviors. Such was the case with Rumpelstiltskin, a conniving magical dwarf who offered to spin straw into gold for the miller's daughter. At first this seemed like an act of kindness, given for a small price. But Rumpelstiltskin's true nature was soon revealed when he demanded a much higher price for performing the same task again—the girl's firstborn child.

► STEP 1
I begin with my line drawing. Rumpelstiltskin is elusive: He's neither human, nor beast, so he comes entirely from my imagination. While he's a trickster, and not good by any means, he's also not scary.

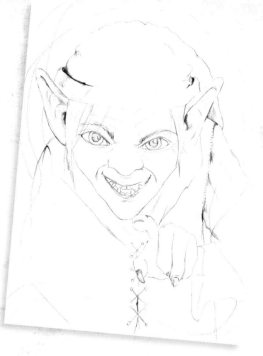

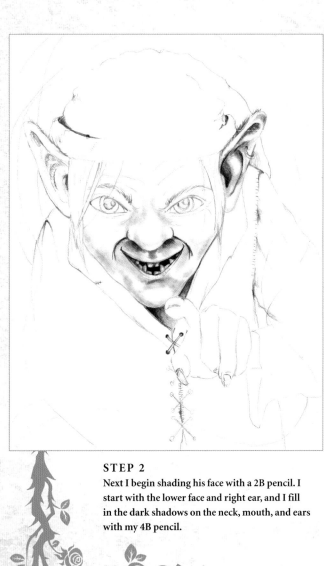

STEP 2
Next I begin shading his face with a 2B pencil. I start with the lower face and right ear, and I fill in the dark shadows on the neck, mouth, and ears with my 4B pencil.

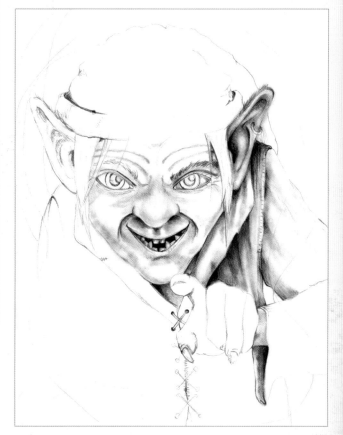

STEP 3
I start shading the clothing, adding the darkest values in the shadow areas and creases first. Then I start adding some of the midtone values in the face.

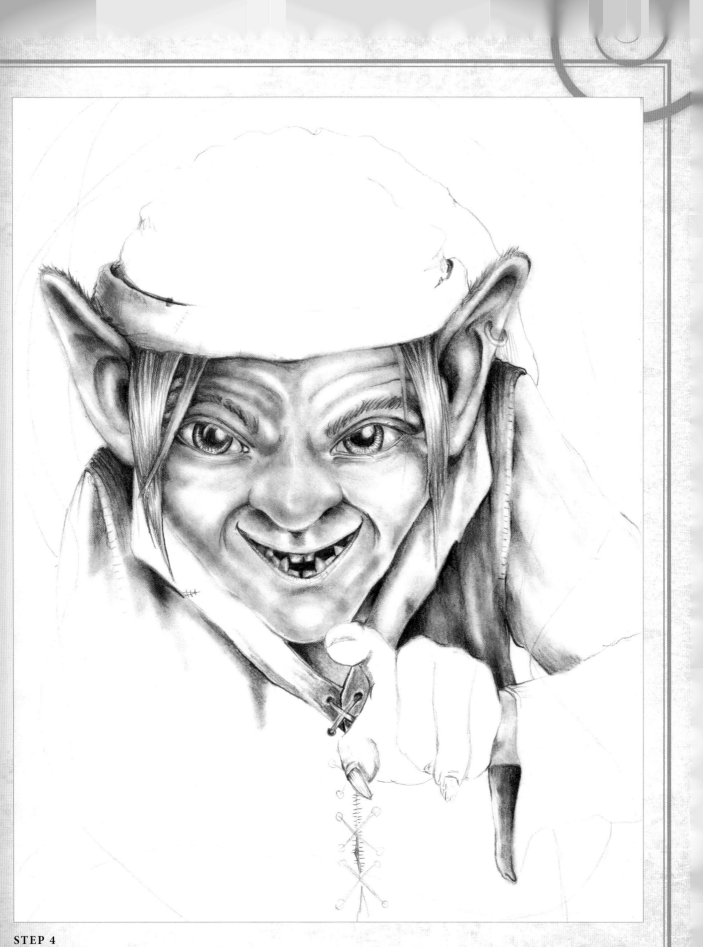

STEP 4

I continue adding tone to the face and on the other ear, blending with a cotton swab as I go. Don't forget the tiny hairs along tops of both ears. The eyes are very important—they show his intentions and give us a glimpse inside, so don't skimp on the details! I shade the dark pupils and outer edges of the irises with a 4B. Then I draw fine, feather lines in the irises with a 2B.

STEP 5

Next I work on the hand, which is slightly clawlike, but not too sinister. I also work on shading the hat, using my 4B pencil for the dark shadows and a 2B for the lighter values.

STEP 6

I blend my shading, especially on the face. I want Rumpelstiltskin to be in the shadows, which will add to the depth and mood of the drawing. I darken the side of his face and body for a shadowy appearance. Then I start filling in the background with a 9B pencil.

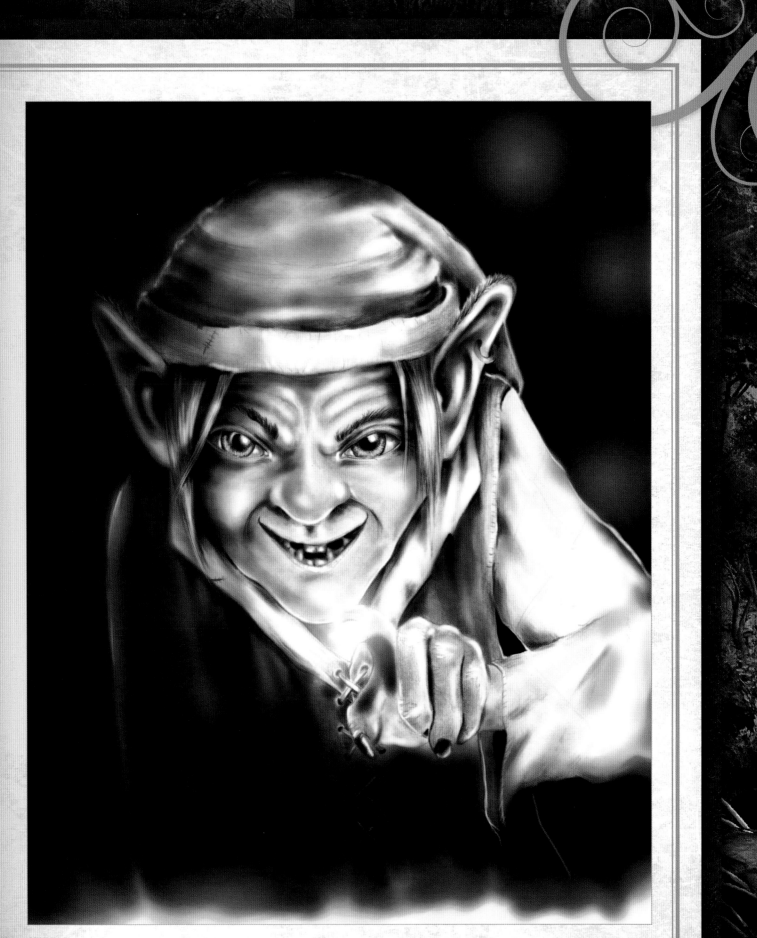

STEP 7

I finish filling in the background and make any final tweaks. Then I scan the drawing into the computer. In Photoshop, I add in some yellows and gold to make him the creature with the "golden touch." I use a pale, glowy yellow on the pointing finger and a more golden yellow in his irises. I also add three radiating orbs in the background to add some dimension.

STEP 8
At the bottom of the image I paint in some spiky golden straw. I keep it soft and blurred so that the emphasis stays on Rumpelstiltskin. Then I add thin golden threads swirling around.

STEP 9

To finish, I add some dimension and movement to the golden thread by going over parts of it with several yellow colors.

Robber Bridegroom

This is the guy you never want your daughter to bring home for dinner. Dark, dangerous, and charming, the Robber Bridegroom comes courting...but he's not looking for someone to wash his clothes. He and his pack of villainous friends could put most serial killers to shame, for they leave a dismembered trail of female victims behind, whose sawn limbs have been boiled and eaten.

STEP 1

I begin with a line sketch that shows the shape of the characters, positioning them to create the most dynamic mood.

STEP 2

I transfer my sketch onto drawing paper and begin the darkest shadows on the faces. I work on both faces with my 2B and 4B pencils to shade the shadows and contours, occasionally blending to achieve smooth skin. I use a kneaded eraser to pull out highlights. I lay down the shadow of beard stubble on the Robber Bridegroom to make him more rugged and manly, dotting my pencil over the jaw and alternating between light and dark.

STEP 3

I begin to work on the hair to give it shape. Remember that when you draw hair, you don't need to draw every strand. Work with shapes and mass—the viewer's eye will fill in the rest. I also shade the neck and collar on the Robber Bridegroom.

STEP 4

Next I turn my attention to the clothing. I focus on the small details first—the embroidery on her dress strap and the laces on his shirt. Then I begin shading the fabric. I use a 4B pencil to shade the shadowed parts of his shirt and a 2B for some of the lighter areas. I also develop more of the girl's hair, using lines in various lengths and darkness to suggest strands of flowing hair.

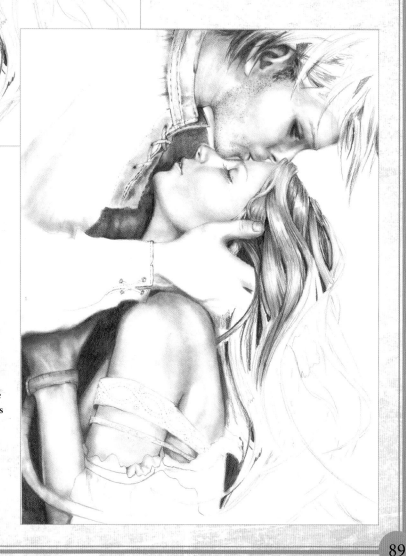

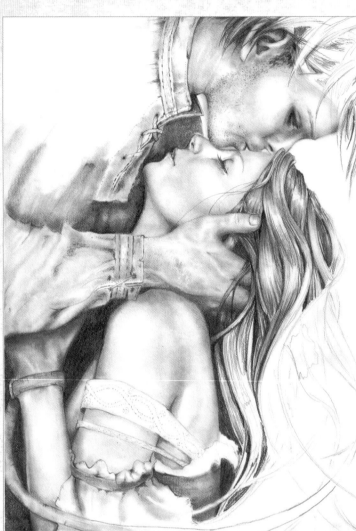

STEP 5

I work more on the girl's hair with my 2B pencil. Note how I leave spaces of lighter tone in the hair for highlights. I move to the Robber Bridegroom's hand and shirtsleeve. Hands can be tricky; you might find it helpful to work with reference photos to achieve the right shading. I also shade the bodice of her dress and the shadows on its sleeve.

STEP 6

I finish filling in the hair on both characters. Remember to focus on shapes rather than individual strands. I use lots of curving lines for the girl's hair and straight, tapering lines for the Robber Bridegroom's hair. I finish shading his shirt, paying careful attention to the positioning of the shoulder and arm. I scan my drawing into Photoshop to start deepening the shadows. You can also use charcoal or a 9B pencil if you don't plan to work digitally.

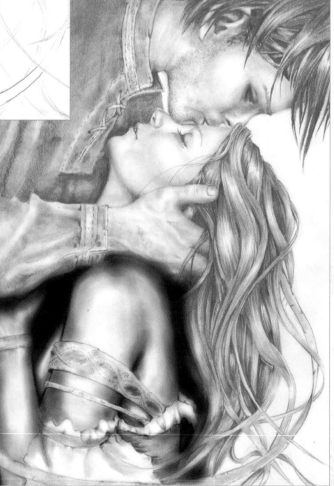

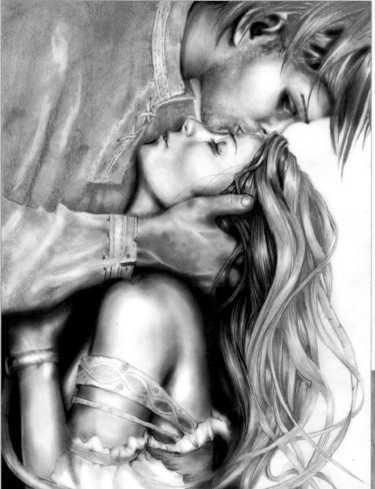

STEP 7

I start to deepen the shadows in her hair. Then I add in the dark shadows in the Robber's hair and ear. I also work on some of the facial details, pushing the darkest areas around the eyes and refining the lighter shadows around their noses, cheekbones, and lips. I add a small shimmer near the girl's eye for a tear, and I add more stubble on the Robber.

STEP 8

I fill in the background with black but add light behind the Robber to illumine the heads. You can do this digitally, or you can fill in the background with charcoal and use white charcoal or pastel. I firm up the shape of the Robber's hair and finish darkening it.

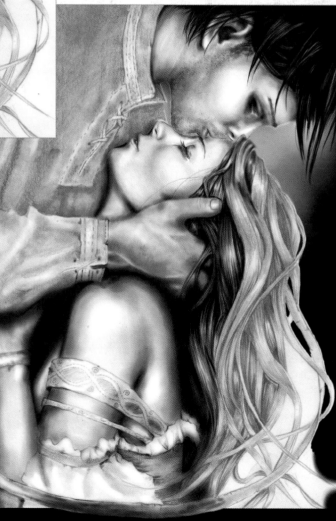

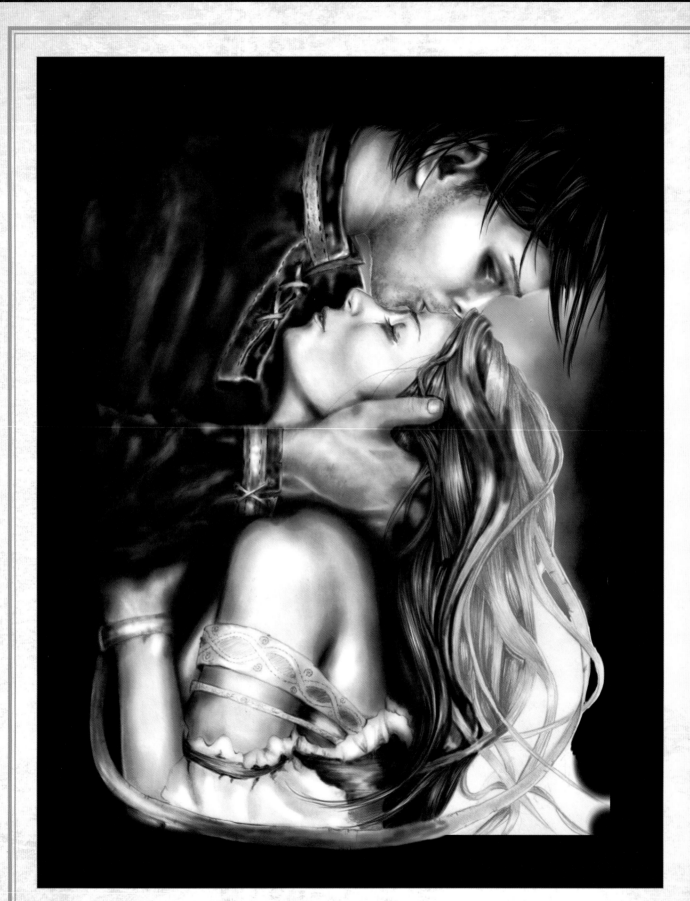

STEP 9

I darken the Robber's shirt and add in some details to make it appear more realistic and textured. I work on one area at a time, starting with the darkest shadows and leaving areas of highlight. I build around my darkest shapes to create the look of fabric. I also add a little more shading to the girl's hair.

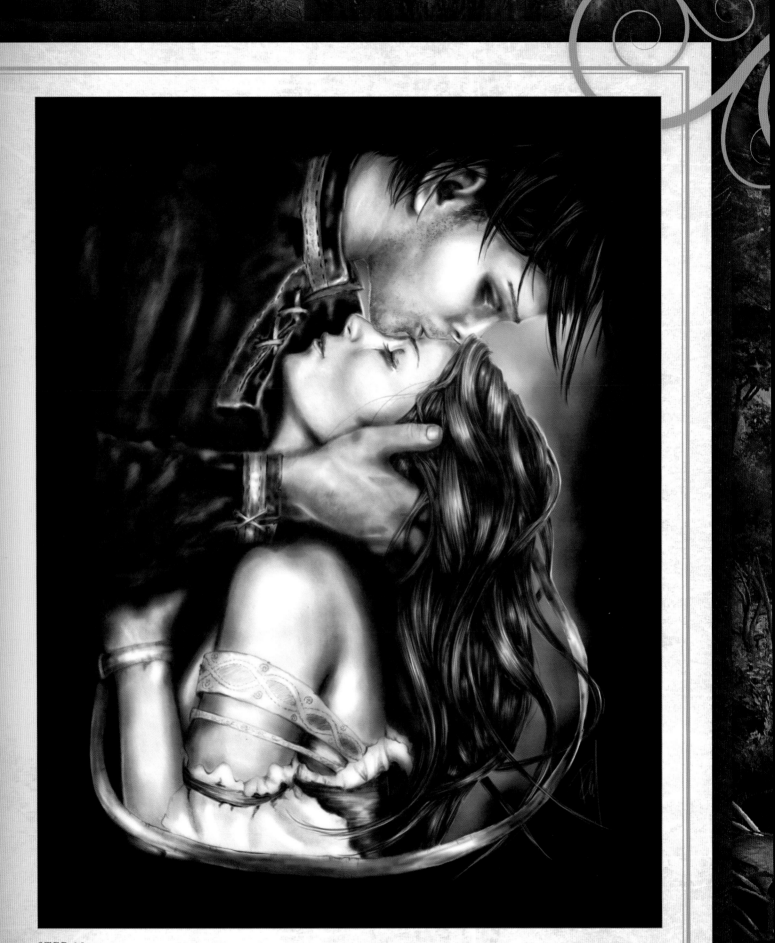

STEP 10

I finish detailing the girl's hair. I increase the darkness of the shadow along the top of the girl's shoulder and down her back, where her hair meets her skin. I also work on the background more, allowing the light to fall behind her to help her hair to stand out, as well as highlight the shape of the final image.

Evil Queen

Don't be deceived by her beautiful exterior. On the inside, the evil Queen is as dark and devious as a troll, willing to kill children—even her own stepdaughter—to get what she wants. Versed in the dark art of magic, she also possesses the skills of an assassin. This is one person you wouldn't want to tuck you into bed at night.

STEP 1

I'm going to digitally illustrate my evil queen, but first I create a line drawing. I like to do most of the initial figure stage in pencil first, but you can do the whole piece digitally if you prefer.

STEP 2

I start adding in the shadows first, beginning with the darker side of her face so I can build up the layers of pencil as I go. These shadows are pretty dark. I use a 9B pencil for the darkest shadows and 4B or 2B for the lighter areas.

STEP 3

I adjust the jawline a bit and continue shading the rest of the face and down her neck. I add some details in her eyes.

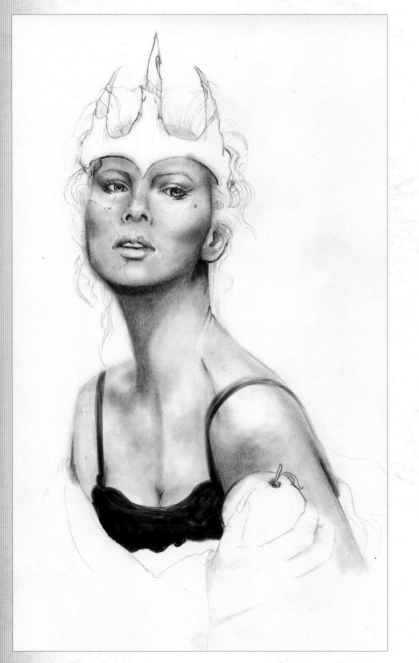

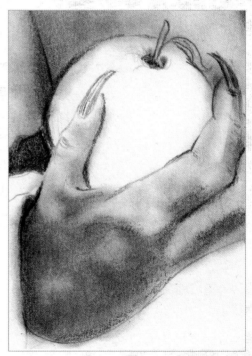

STEP 4

I lightly blend the shading on the face to even out the tone and lift out graphite with a kneaded eraser for the highlights. Then I work on the shape of her chest and arms. I fill in the dark line of the top of her dress and add straps.

STEP 5

I turn my attention to her hand and begin to add shading. Reference photos are helpful for rendering hands. Pay attention to line details and textures.

STEP 6

Next I scan my drawing and create a new file in my painting program. I add my scan into the file as its own layer. I name my sketch layer "Grayscale" and then add a third layer, naming it "Skin." I choose the base shade for her skin tone and paint it onto the "Skin" layer above my drawing. I erase any excess paint with the eraser tool. If your color is too striking, you can adjust the opacity of the layer, which will allow more of the drawing to come through. I create a layer for shadowing, as well as a separate layer for highlights. Keeping each part as its own layer makes it easier to fix any mistakes.

STEP 7

I add more color to the skin layer and paint the lips. I use a couple of highlight colors to lighten the top of her cheekbones, brow bone, nose, and chin. I strengthen the beauty mark and the whiteness of her eyes. I color her eyes violet to add a fantastical look. As you work, play with the opacity of your brush. I like to use a soft round brush, and I prefer to work with a lower opacity and apply multiple layers so I have more control over the color.

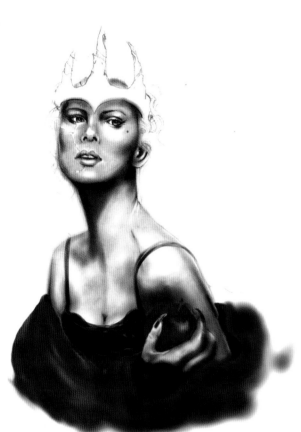

STEP 8

Once I'm satisfied with the skin tone and texture, I move on to the clothes and apple, creating a new layer for each. Here's where the color begins to make your painting pop! I choose royal colors because this evil beauty is a queen. I use various light and dark shades of my chosen colors to create depth and dimension.

STEP 9

I want the apple to look sinister, so I add in some dripping blood to show how deadly it is. Then I make a new layer for the crown and hair. I start painting in the texture, adding scratches and sharp shadows. The frame of the crown is dragon bone, so I use pale green and yellow to paint the parts that show through the metal. I also start defining the curly tendrils of hair on either side of her face.

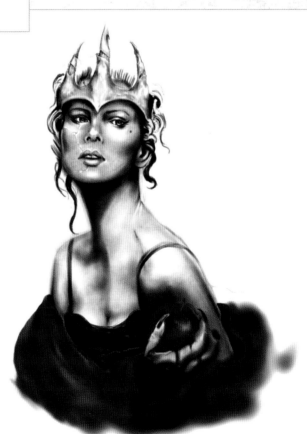

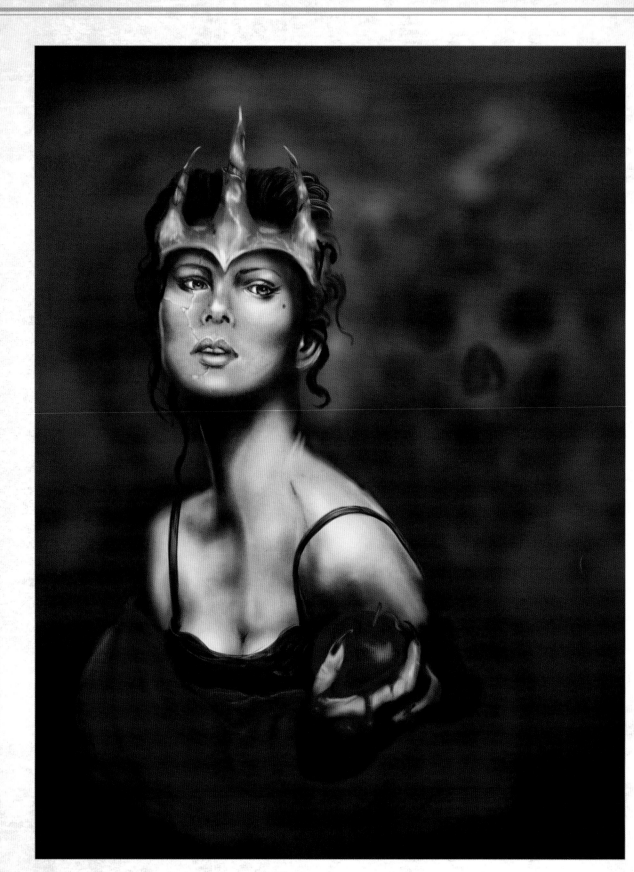

STEP 10

I create a new file in my program and use the bucket tool to fill it with black. Then I paint in the fog with the soft round brush tool, adding a foggy skull. I create a new layer for the background in my main piece; then I copy and paste the new file onto the new layer. I finish detailing her hair and add highlights on the shiny tips of the crown.

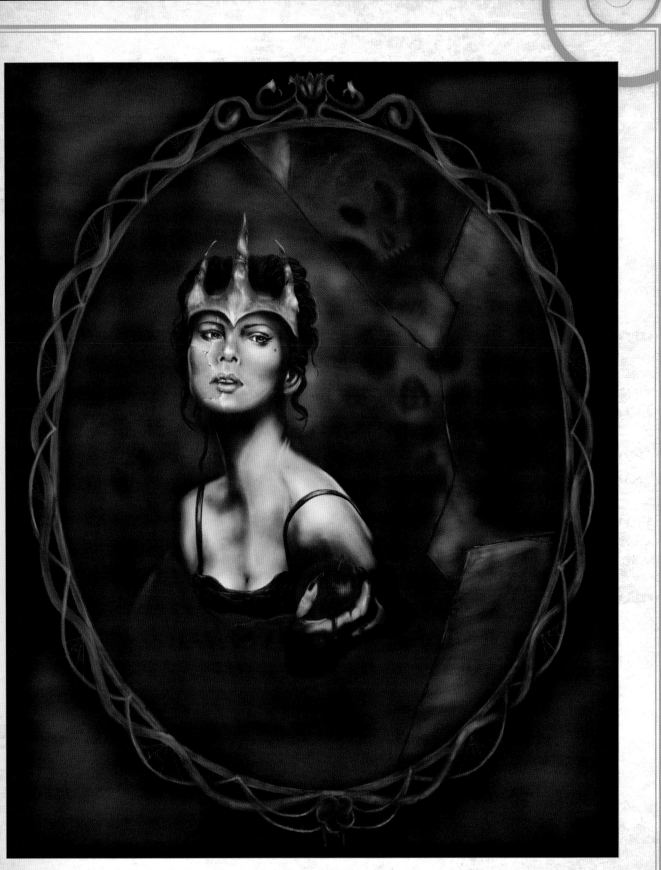

STEP 11

I want my finished piece to be of the queen's reflection in a mirror, so I create a new painting in my program and use the oval tool to place a mirror shape. Then I add my finished painting as its own layer and use the oval as a guideline to build up the structure of the mirror. I add several cracks to echo those in the queen's face, and I add a few more foggy skulls in the background. I also add a few subtle spider webs in some of the curves to give the lovely frame a sinister feel.

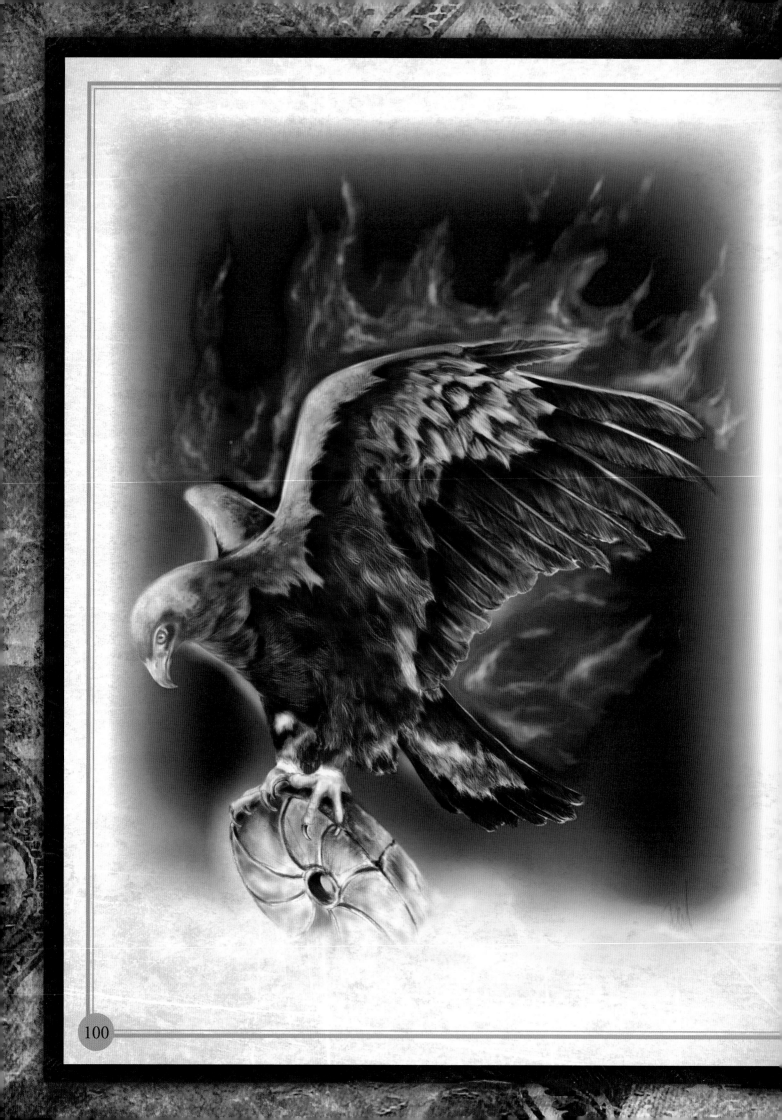

Chapter 4

BEASTS & CREATURES

Almost anything can happen in a Grimm fairy tale, which is one of the many reasons why people have loved these stories for centuries. The presence of unusual beasts and creatures in these tales adds a wondrous, supernatural dimension not found in ordinary stories. During the age of oral storytelling, this fascinating element is what made listeners lean in closer to give the storyteller their undivided attention.

Talking wolves, half-human/half-fish nixies, boys-turned-ravens, resurrected children, and birds singing poetic tales of murder are what make these stories so memorable. Laced with lessons of morality, where good triumphs over evil, these tales are meant to be stored in the heart.

In a Grimm tale, the love of a sister is powerful enough to save her brothers from a spell that has turned them into ravens. She has to make a great sacrifice and cut off her own finger to unlock the door that holds them prisoner. In the process, she becomes a hero and a symbol of familial love.

Likewise, in the Grimm version of "The Juniper Tree," a phoenix—or singing bird— rises up after the murder of an innocent child. This bird cries for justice until the murderer is put to death and the child is brought back to life. The idea that the birds tell the world of the crime leaves a strong impression.

These are the sorts of tales that give people hope, embedding within them a sense of right and wrong.

Big Bad Wolf

Clever and conniving, the Big Bad Wolf doesn't care if he's tracking children or huntsmen or pigs. His goal is always the same—do whatever's necessary to win. Armed with skills that make him the stuff of nightmares, this beastly villain can reason, argue, and deceive better than a politician. Plus he's been gifted with the razor-sharp teeth and dagger-like claws of a serial killer. All good reasons to stay out of the woods.

STEP 1

After I'm happy with the composition of my line drawing, I start adding detail to those long, sharp teeth. Keep in mind how the fur should shape around the mouth and how the moonlight will create sheen on the snout. I shade the fur around the mouth lightly with a 2B pencil, using a 4B for the darkest areas along the bottom jaw and in the ear. I also lightly shade the outer edges of the moon.

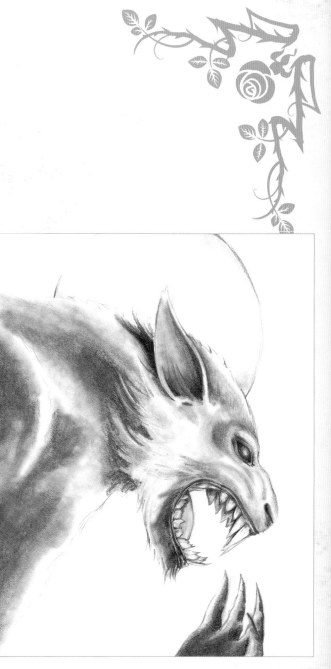

STEP 2

I shade the rest of the body simply, adjusting my pressure on the pencil for darker and lighter tones. The light and dark areas will help me map out the fur in future steps.

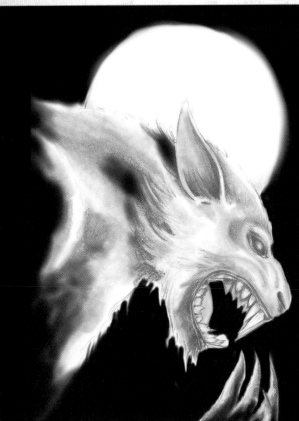

STEP 3

Next I color the background with rich black. You can choose to do this digitally, or you can use charcoal or pastel.

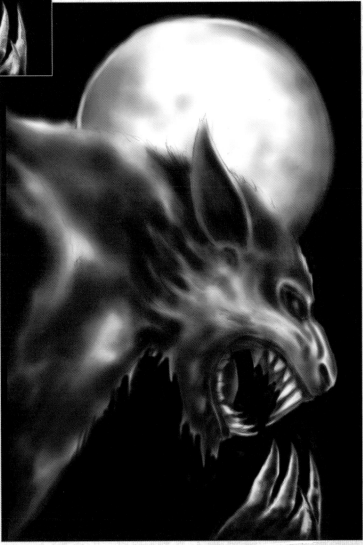

STEP 4

I go back to the beast's fur and darken the undercoat. I use a soft round brush tool in my digital painting program, but you can also use pastels or charcoal and cotton swabs to blend the color. I also begin working on the moon.

STEP 5

I begin laying down more detailed fur. When working on the fur, focus on direction and color—the strands shouldn't all be the same color. I vary the depth of the grays from light to black, using the shadows of the undercoat as a guide. I also color in the evil red eye, leaving light reflection in the middle.

STEP 6

This beast has just had dinner—hopefully not anyone in a red hood—and he's a bit of a messy eater. I add some streaks of blood in the fur, especially under the mouth. I also paint some blood still dripping from the teeth and staining the claws. To finish the illustration, I add some red to the bottom half of the moon to make it a blood moon. Now my monster is ready to stalk the night.

Seven Ravens

A young maiden traveled to the ends of the earth, fleeing from a cruel sun and moon, and befriended by kind stars. All this she did to find her seven brothers, who had been turned into ravens. When she finally came to the mountain where they were imprisoned, she had lost the key made from a chicken bone. Here, she made the ultimate sacrifice—she cut off one of her own fingers and used it to open the door and free her brothers.

▶ STEP 1
I begin by sketching out my composition. I want two things to be prominent—the sister and a large raven. I focus on these two elements first and then sketch in the door and a border of vines.

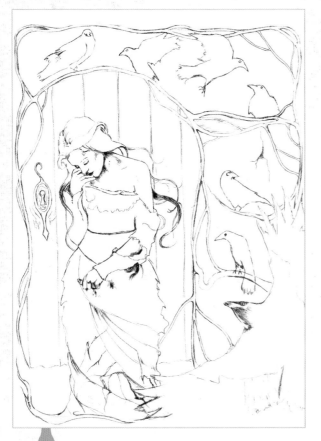

STEP 2
I place the rest of the birds and add detail to the door and some hatching on the largest raven and the sister.

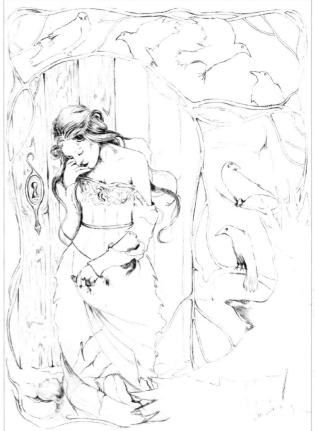

STEP 3
I begin sketching in a wood grain pattern and add detail to the top of her dress. I also start working on her hair.

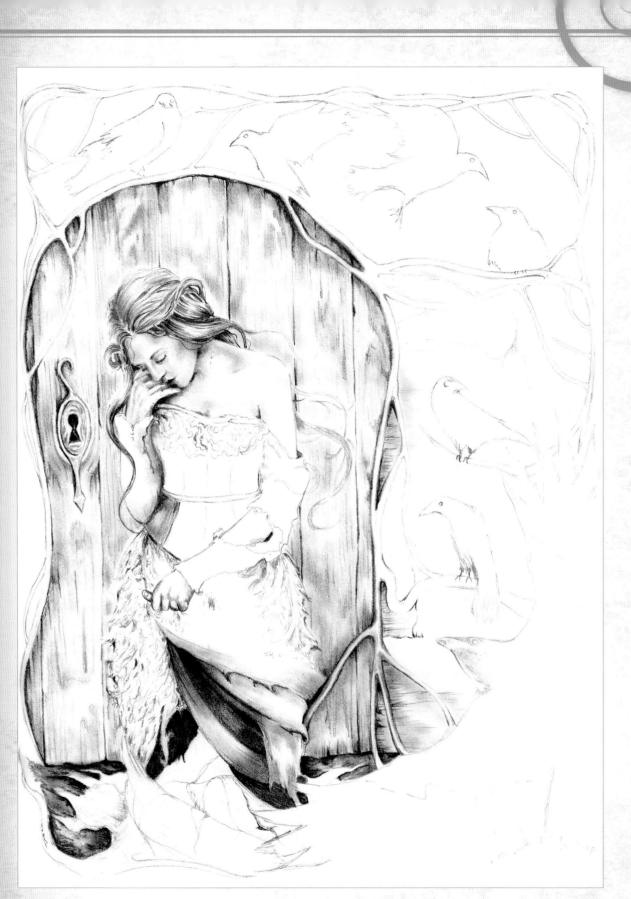

STEP 4

I finish drawing in the wood grain and lightly blend with a cotton swab to soften the lines. I start filling in the depth of the floor and some of the dress details with a 4B pencil. I also begin to fill in the shadows of her face with a 2B pencil. Her hands are very small, so I use my sharpest pencil and focus on getting the details right.

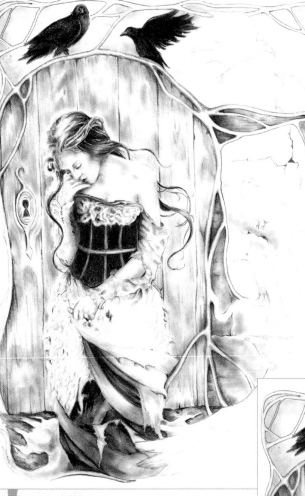

STEP 5

I work on the details of her corset and her sleeves and start filling in the bottom of the dress. I want the dress to be a reflection of how her life has changed, so I try to incorporate a sense of movement. I start filling in the top two ravens with dark tone. You can use a 4B or 9B pencil. I smudge in light tone on some of the wall. I also spend time working on her hair and rendering the flowing strands.

STEP 6

I want to keep the wall fairly simple so it doesn't detract from the ravens. I shade the entire wall with light gray tone, using horizontal strokes and a 2B pencil. Then I go back to add some darker areas and the cracks with a 4B. Next I shade the other four ravens.

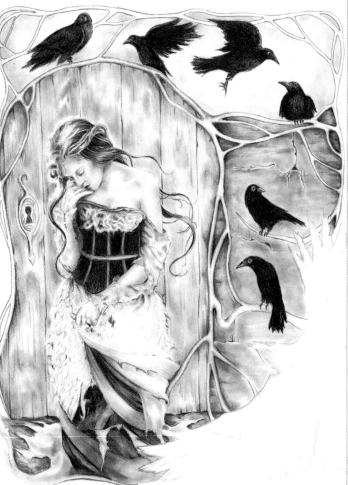

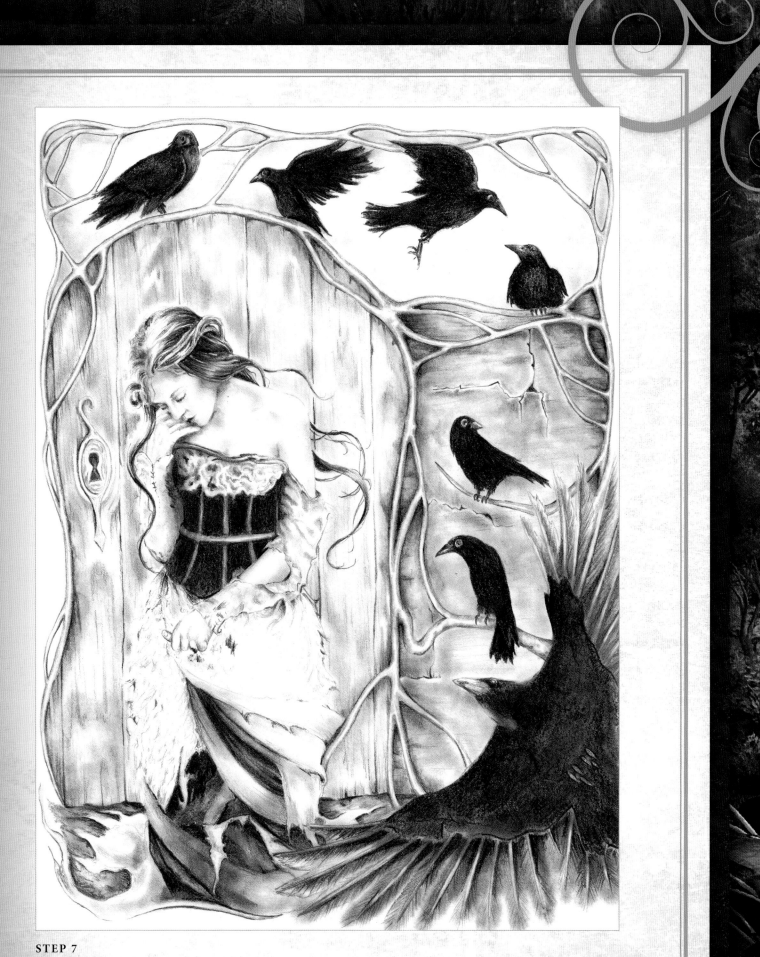

STEP 7

I want the largest raven to be as detailed as possible. I used some reference photos of ravens in flight to help me grasp the bird's anatomy. I shade in the body with my 4B, as well as the shadows along the feather veins of the bottom wing. Then I draw small thin lines along the feathers, blending gently.

STEP 8

To draw attention to the cut-off finger, I add blood with a red marker and colored pencil. I deepen all my shadows on the door, dress, and hair. I use a black marker to darken the darkest shadows. Then I scan my drawing into Photoshop to clean up and add further shadowing. I use the dodge tool to create the rays of light bursting from the keyhole.

STEP 9

I work more on the larger raven. As a focal point, he requires a lot more attention and detail. I work on darkening the shadowy tones in his body, leaving areas a little bit lighter for contrast and dimension. I also darken the edges of the illustration and go back over my shadows to deepen them even further. I finish the details on the raven's wings. I also go back to the sister's dress and finish the shadow details. I darken the tone on the remaining ravens so they are mostly silhouetted.

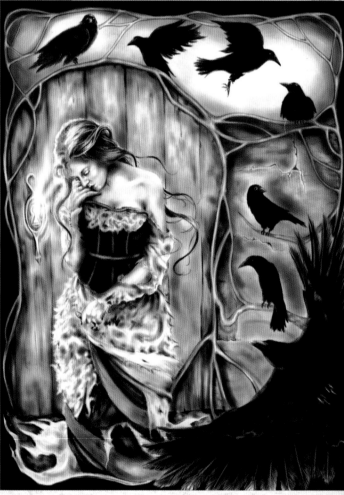

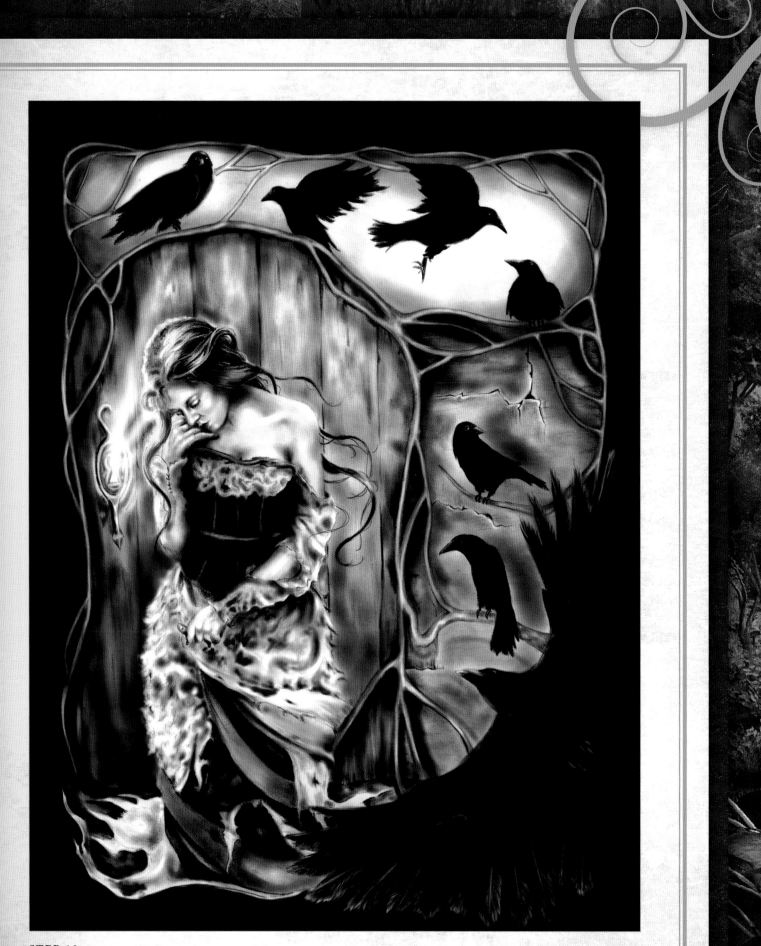

STEP 10

As I finalize my drawing, I add a larger border around the illustration. I add a little more blood on the dress and by the keyhole, as well as in the bottom left border. I adjust the brightness and contrast using the adjustment feature in Photoshop to really add drama.

Phoenix

A beautiful bird sang a lovely song, enchanting nearly everyone who heard it. But the words of the song told a horrible story—how a woman had murdered her young stepson, cooked him in a black pudding, and then served it to the boy's father. The bird later killed the woman by dropping a millstone on her. At that point, the dead child resurrected in a cloud of fiery smoke and was reunited with his father.

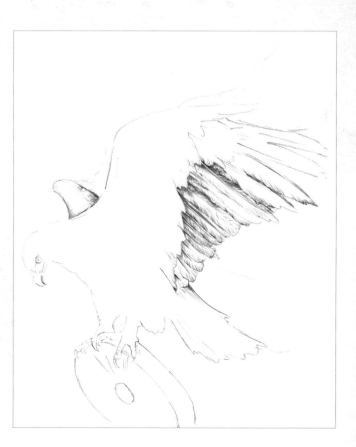

STEP 1
After creating a line drawing, I start shading the wings with my 2B pencil, taking the time to shape them. I then start to render the feather texture, using fine lines to convey the feather barbs.

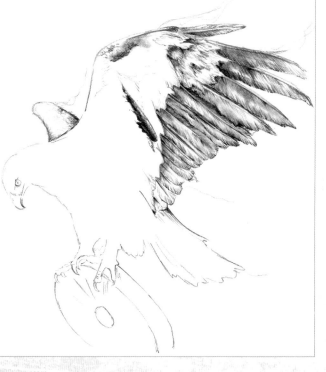

STEP 2
The under feathers are less defined. I begin with a sort of "map," using shading to show me where I will go with the color later.

ARTIST'S TIP

A phoenix is a mythical firebird, but you still want him to look as though he could descend from the clouds at any moment. For this illustration, find some reference photos of real birds. I used images of the most regal bird I could find—the eagle.

STEP 3

I move on to the head and eye and begin shading and detailing the feathers, pupil, and beak. I shade more darkly under the neck. Then I add a few scribble and hatch marks on other parts of the body to start delineating some of the texture.

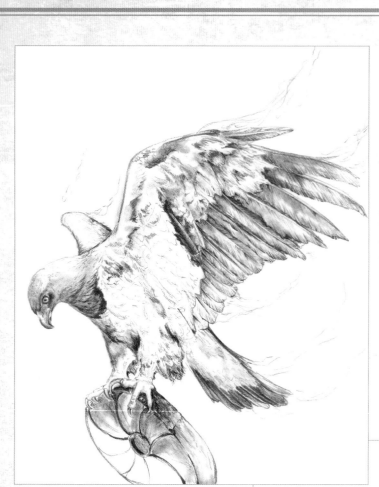

STEP 4

I continue to map out the feather shadows across the body. Then I begin shading the millstone clutched in the bird's talons.

STEP 5

I scan my drawing so that I can start digitally coloring. You can also use pastels, watercolor, or colored pencil to color your illustration. I use my shading map to help as I lay down my base colors so I know where to use darker tone.

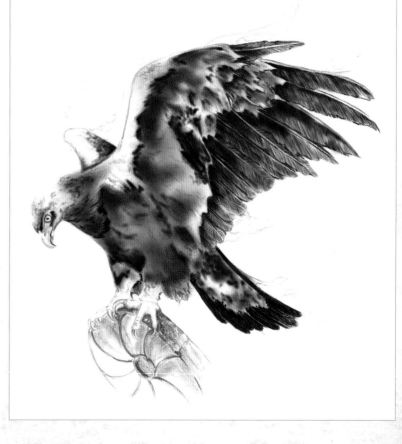

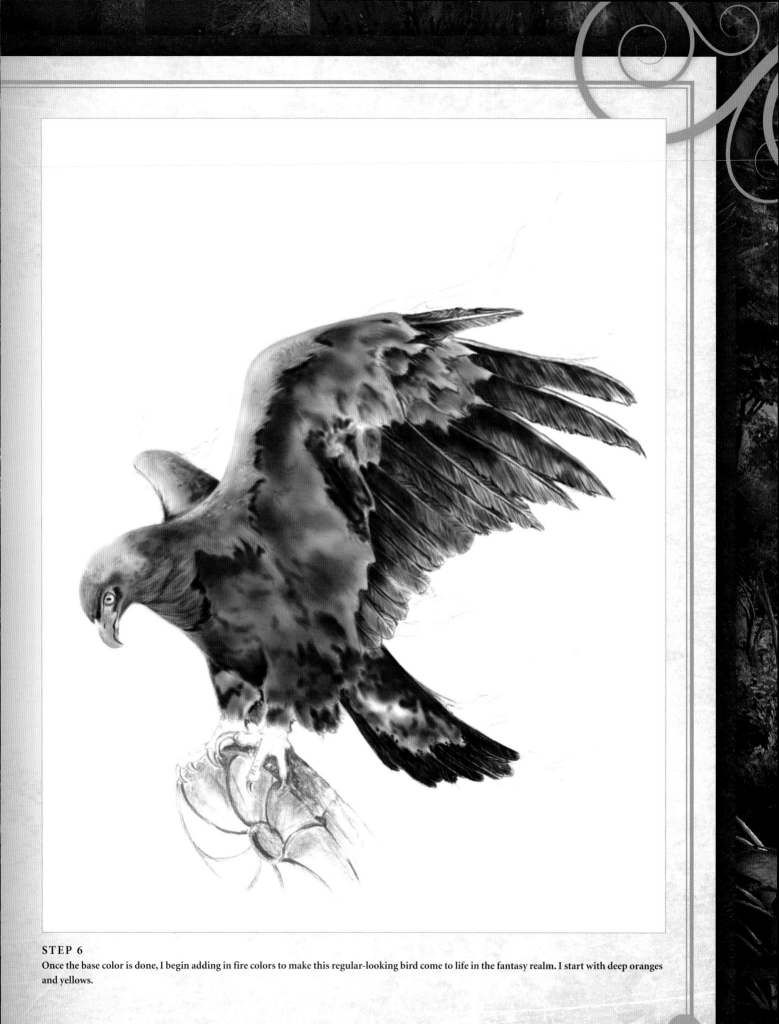

STEP 6
Once the base color is done, I begin adding in fire colors to make this regular-looking bird come to life in the fantasy realm. I start with deep oranges and yellows.

STEP 7

I continue adding color, using various shades of orange and yellow. You can use as many shades as you'd like, but don't forget to leave some of the white uncovered so the "puffy" look of the feathers doesn't get dull.

STEP 8

I add a bit of red on the front of the bird. Then I finish up the areas of softer feathers on the tail and legs.

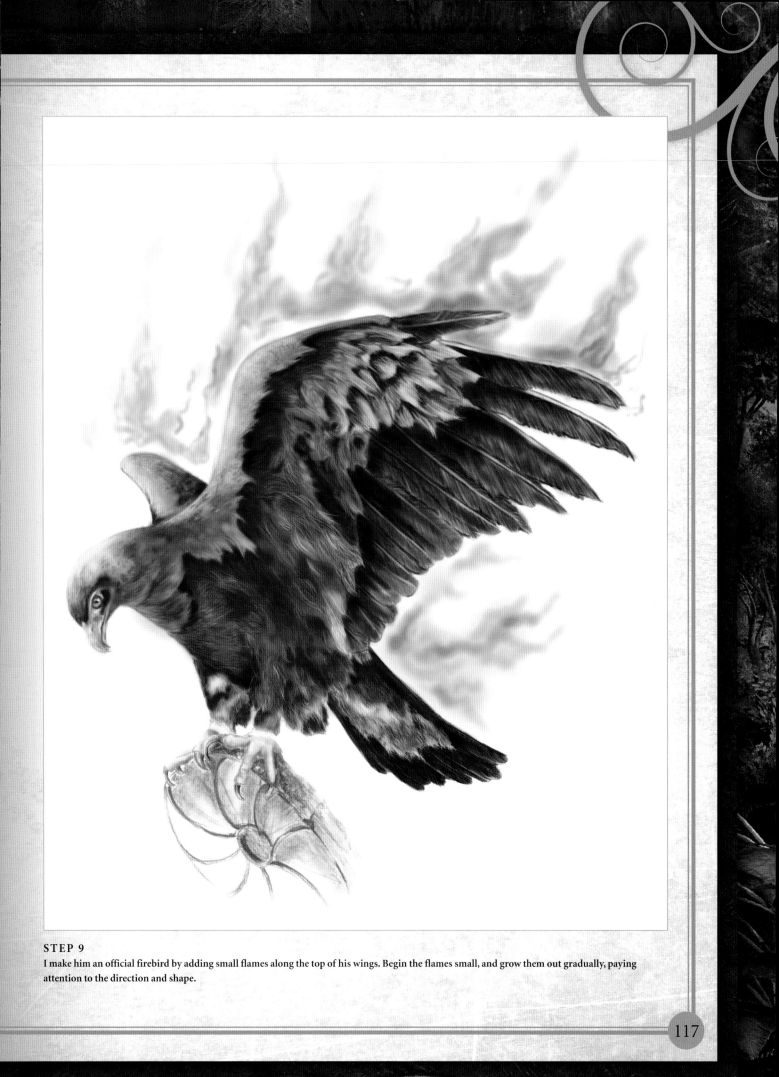

STEP 9
I make him an official firebird by adding small flames along the top of his wings. Begin the flames small, and grow them out gradually, paying attention to the direction and shape.

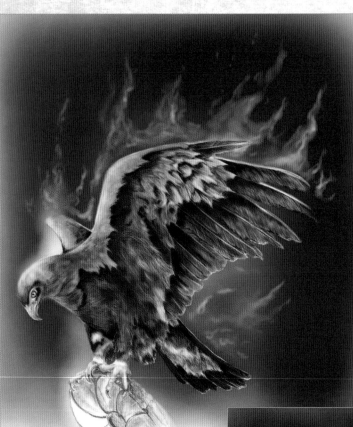

STEP 10
I add in a bright blue background, which adds life to the illustration. With the background in, I tweak the flames.

STEP 11
I add clouds below the phoenix, giving him the illusion of height. I keep them nice and fluffy and add a bit of yellow to the tops for fire reflection. I also add some purple to the sky for balance.

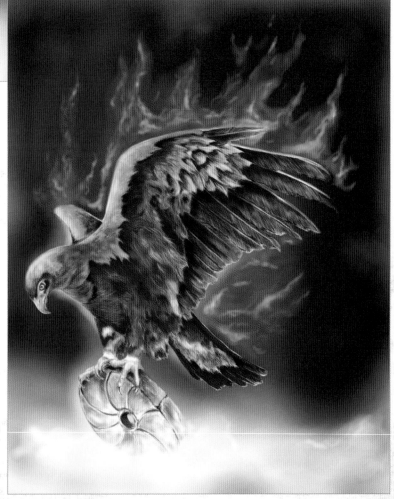

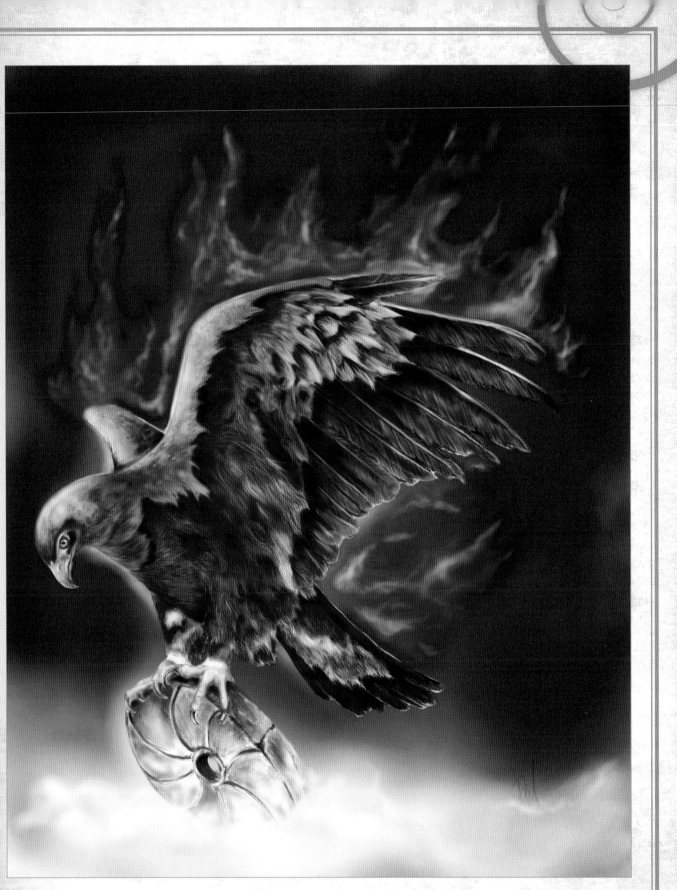

STEP 12

I make some final touch ups. Then I use image adjustments in Photoshop to brighten the colors and sharpen the lines. Even if you have colored your artwork with traditional media, you can still scan and alter it for added impact if you desire.

Water Nixie

A strange, evil creature—half-human and half-fish, with the ability to shape-shift—lived at the bottom of a well. Called a water nixie, she captured two children and forced them to work for her. One day, while the nixie was at church, the children fled, casting a mirror behind them that turned into a slippery hill of glass. Even though the nixie cut through the glass with an ax, she was too late. The children had escaped.

▶ STEP 1
As I work out my sketch, I focus on layout and character design. Once I have my ideas clear, I start the line drawing. I don't put much detail in this stage. I just want to get it onto the paper and become comfortable with the main body.

STEP 2
As always, I begin by shading the face with a 2B pencil. I focus on the darkest shadows first and outline the eyes and lips. I also add some shading to parts of her hair and define some of the details of the finlike ear.

STEP 3
I add a bit of scaly texture to her forehead and then I start shading the rest of her body. I add details sparingly to start suggesting the moss and scales that coat her skin.

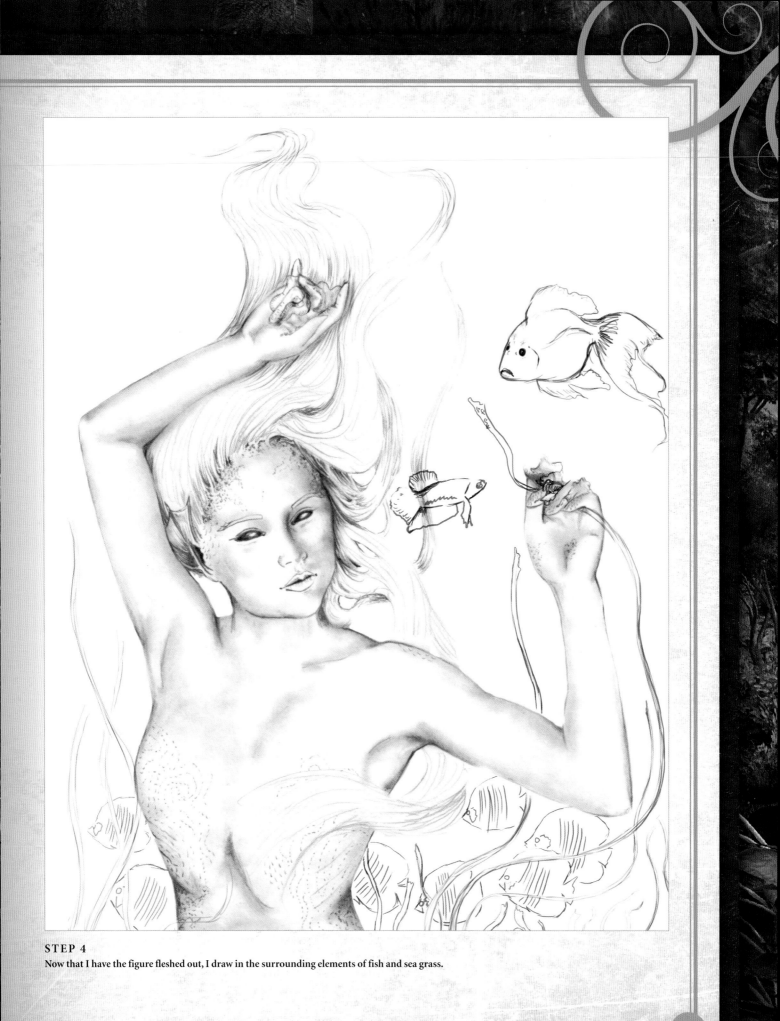

STEP 4
Now that I have the figure fleshed out, I draw in the surrounding elements of fish and sea grass.

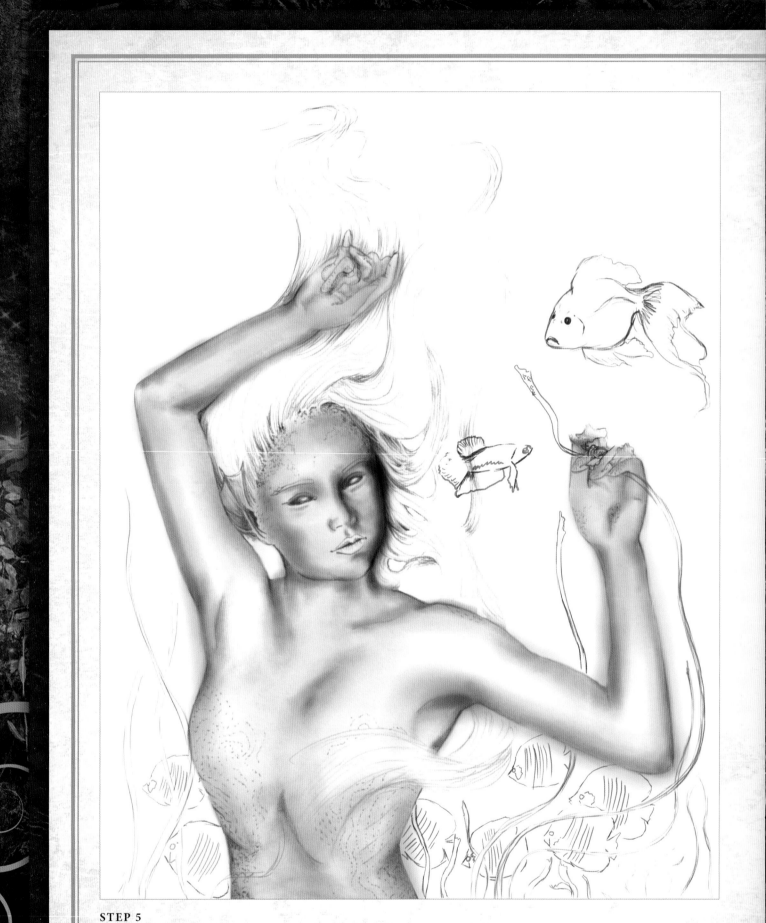

STEP 5
I paint the body in three stages. First I lay down a base color. Then I add darker tones for shadows to create depth. Lastly I add in detail work. To start, I choose green for her skin. As I progress I'll add in other colors to reflect the light and textures of the water.

STEP 6

I add more green tones to her skin, using a variety of bright and dark shades. I also add hints of deep purple in the shadows. Then I darken the shadows along the side of her face and torso. Even though her face is humanlike, I keep in mind that I'm not drawing a human figure. I make her face more angular and color her eyes black.

STEP 7

I "trim" the green paint around her body with the eraser tool, giving her clean, smooth lines. Then I start focusing on the fishy details on her body. These fine details take a bit of time, but it's worth it to get the proper effect. I give the gills at her rib cage more depth and add in scales and moss in a pattern on her flesh.

DETAIL

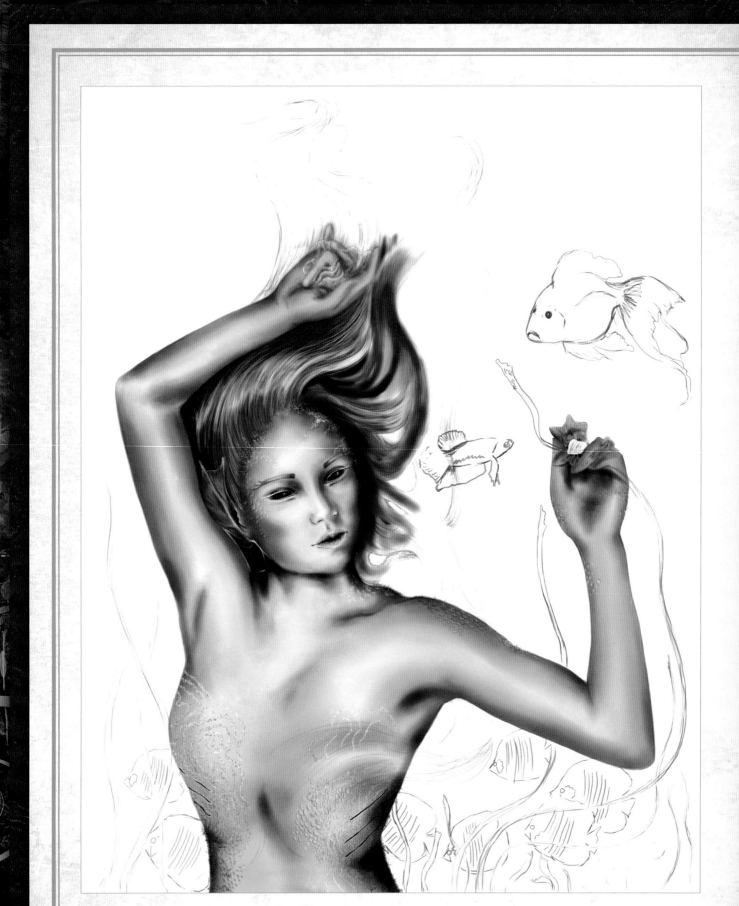

STEP 8
Next I start working on her hair. I lay down a base layer of purple first and then go back in with various purples, greens, blues, and hints of pink. I focus on her hairline and growing the strands out from her skull.

STEP 9

The background is very important for this piece because the scene is underwater. I want to give the feeling of a wide space with light seeping through from above. I make my background on a new layer and experiment with blending dark blues and greens together to get the look I want. Then I focus on using lighter colors in the upper left to suggest the surface of the water, with sunlight breaking through. I also add in shadows of distant plants and coral.

STEP 10

I begin creating shadows to add more depth and create the sense that she is emerging from the shadowy depths.

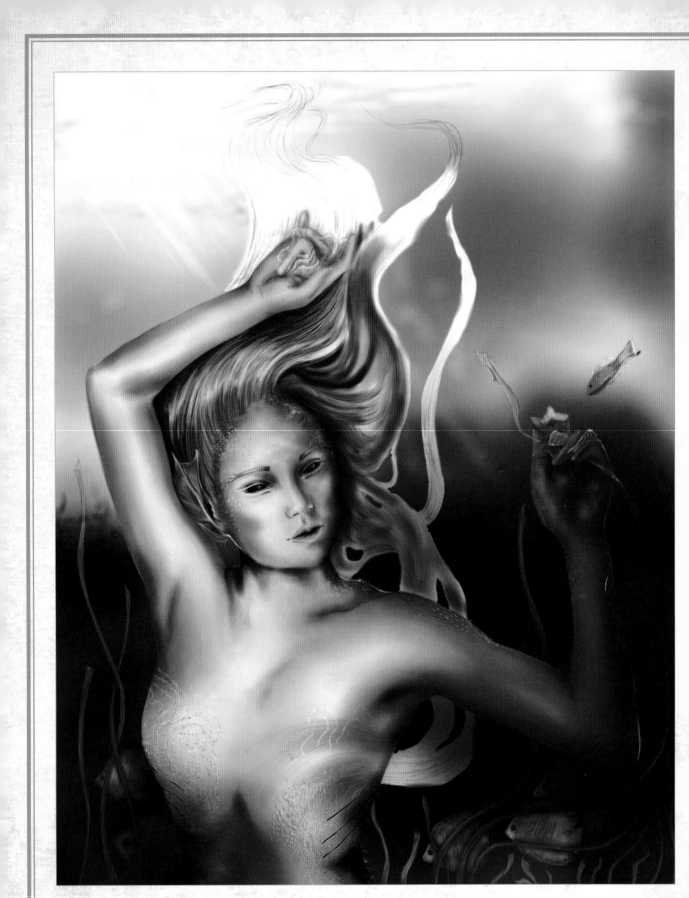

STEP 11

Next I work on the details of the fish and surrounding grass. I decide to get rid of the larger fish because it seems too distracting. I color the fish in shades to match the nixie's hair, which makes her seem like a part of her environment.

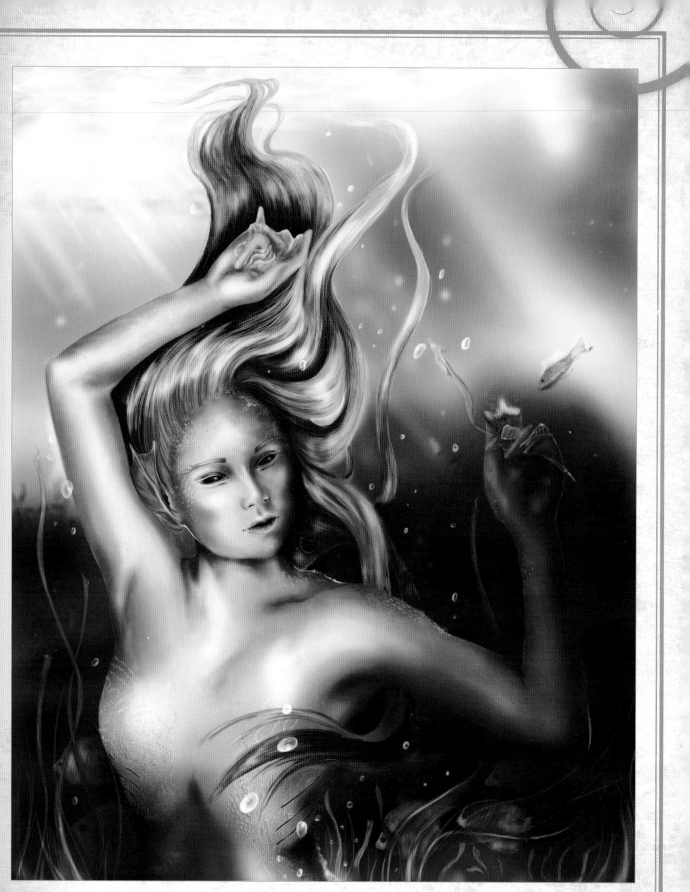

STEP 12

I finish up the nixie's colorful hair by laying down a base undercolor first. Then I go over the hair with various shades of purple, pink, blue, and green, using darker colors for shadow and adding in streaks of white for highlights. This process is time-consuming, so I take a break every now and then. I add some bubbles to finalize the underwater scene.

A Grimm Farewell

Now you know the truth—the Grimm fairy tales you've enjoyed since childhood are full of hidden secrets. More nightmare than sweet dream, these stories aren't about gentle fairies or wish-fulfilling godmothers. They're tales of cannibals; murderers and thieves; hungry witches and wolves; and evil stepmothers, sisters, and queens—every one of them worthy of his or her own Fantasy Underground exposé.

Along your journey through dangerous black forests, you've learned how to draw a swoon-worthy Robber Bridegroom; a cruel-hearted, shape-shifting water nixie; a heroic young maiden who traveled the world to save her seven brothers; and many others. Along the way, you've probably learned not to trust soft-spoken wolves who seek to lead you off the path. In all, you have embarked upon a wondrous journey that will lead you from one Fantasy Underground adventure to another.

See you next time!